MANGA
inspired

monsa

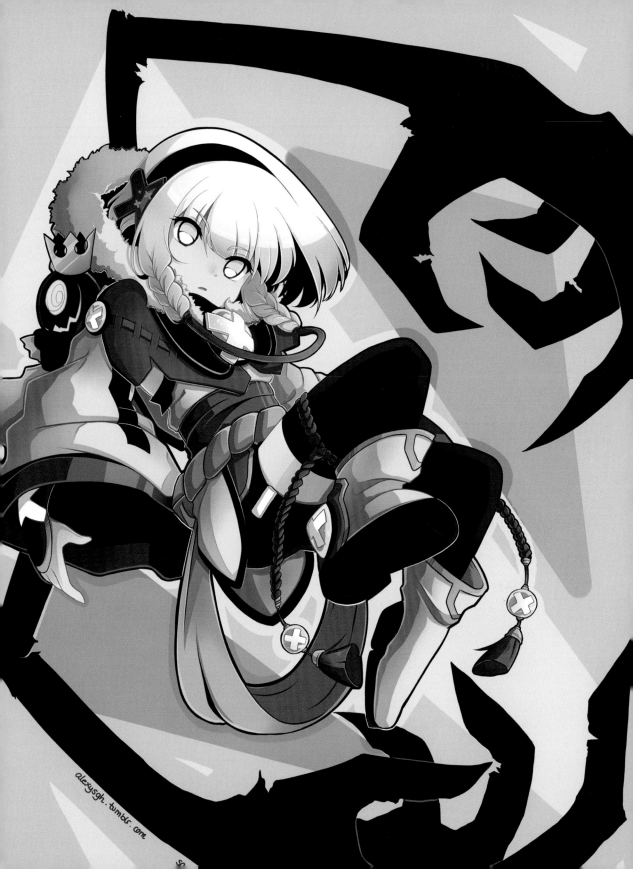

alexysgh.tumblr.com

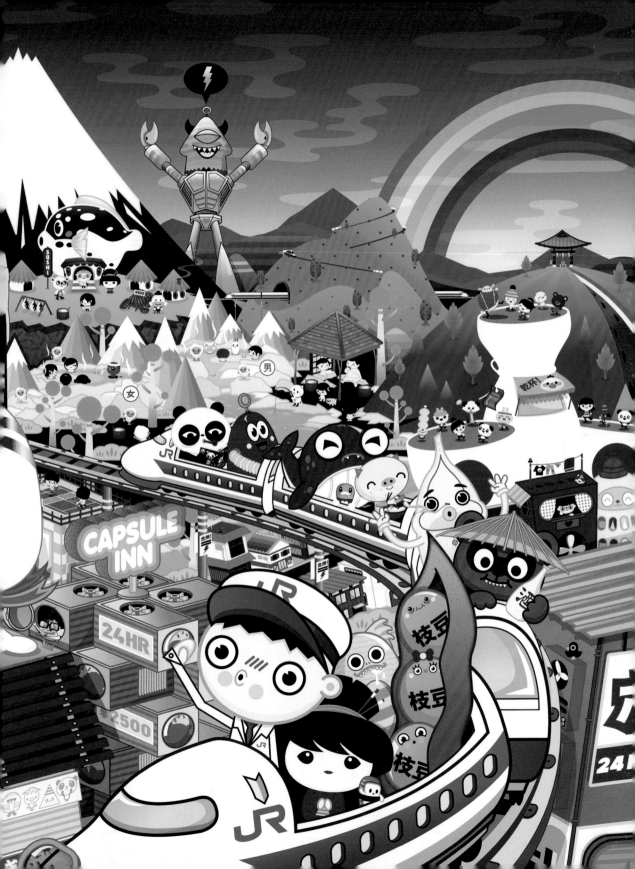

Copyright © 2015 Instituto Monsa de Ediciones

Editor, concept, and project director
Josep María Minguet

Co-author
Eva Minguet

Art director, design and layout
Eva Minguet
(Monsa Publications)

Cover design
Eva Minguet
(Monsa Publications)

INSTITUTO MONSA DE EDICIONES
Gravina 43 (08930)
Sant Adrià de Besòs
Barcelona (Spain)
Tlf. +34 93 381 00 50
www.monsa.com
monsa@monsa.com

Visit our official online store!
www.monsashop.com

Follow us on facebook!
facebook.com/monsashop

ISBN: 978-84-16500-01-7
D.L. B 22223-2015
Printed by Indice

INTRO

A fantastic "Manga" illustration book, that counts with the compilation of twenty-three artists of recognised international prestige. Among them we find Llidoll, Naoshi, Emperpep, Yukiko Yokoo, Andrea Innocent, Akira Ebihara, Sandra G.H., Tado, Devilrobots, Yumiko Kayukawa... that have personally selected some of their best pieces and told us first person which programs they use to edit their work and where they find their inspiration.

We find very diverse styles such as Chibi, Kodomo, Shojo, Seinen, Moe... from the most "Naif", to the extremely personal, to the intensely conceptual or simply expressive.

Un fantástico libro de ilustración "Manga", que cuenta con la recopilación de veintitrés artistas de reconocido prestigio internacional, entre los que se encuentran Llidoll, Naoshi, Emperpep, Yukiko Yokoo, Andrea Innocent, Akira Ebihara, Sandra G.H., Tado, Devilrobots, Yumiko Kayukawa... que han seleccionado personalmente algunas de sus mejores obras y nos cuentan en primera persona con que programas editan sus trabajos, y donde encuentran la inspiración.

Encontraremos estilos muy diversos, como el Chibi, Kodomo, Shojo, Seinen, Moe... hasta la ilustración más "Naif", desde lo extremadamente personal, a lo intensamente conceptual o simplemente expresivo.

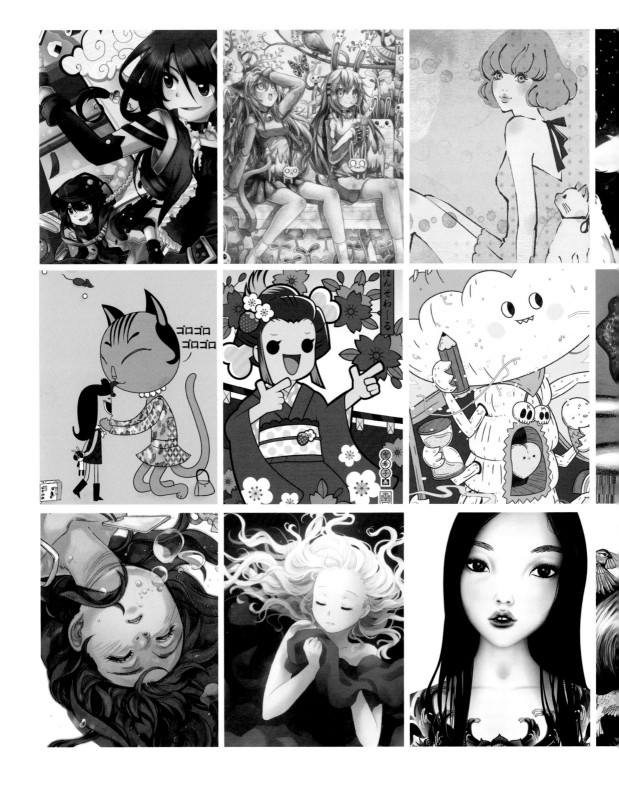

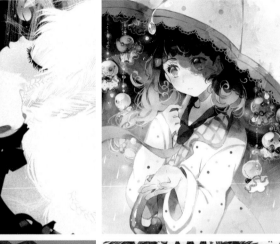
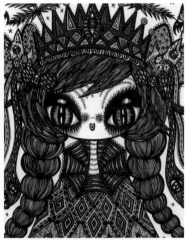
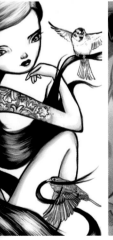
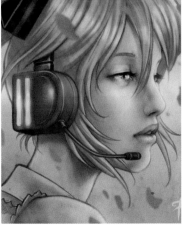

INDEX

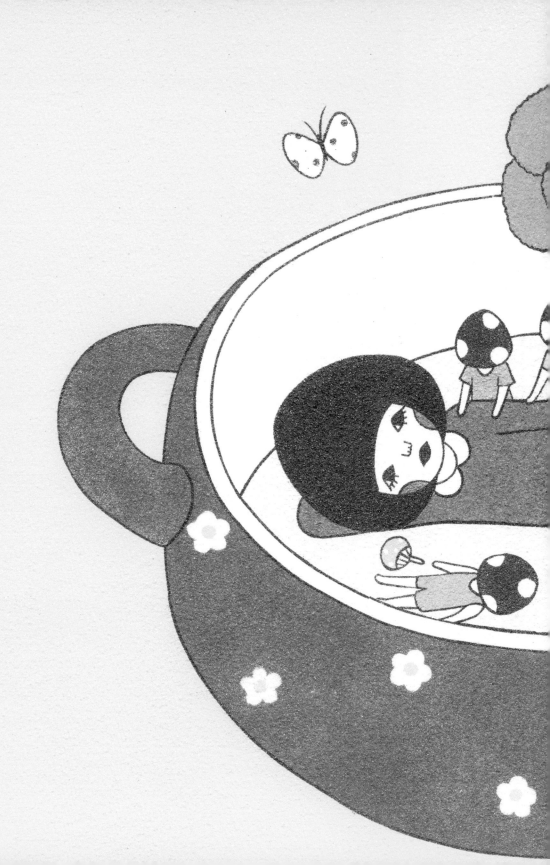

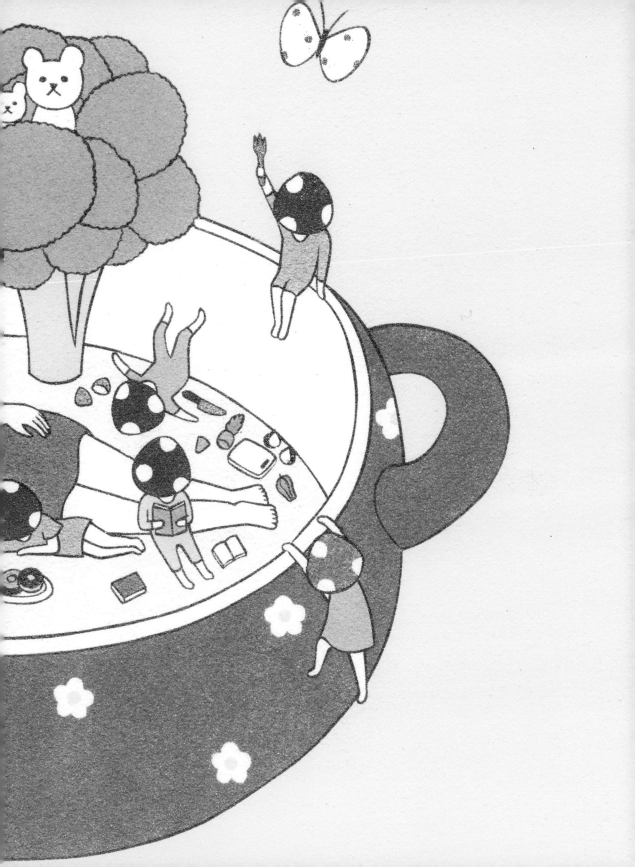

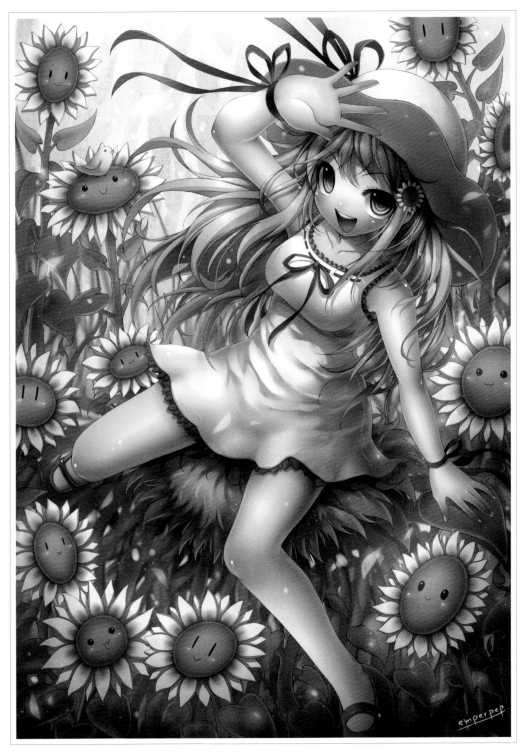

Happy Sunflowers

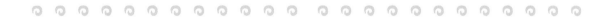

EMPERPEP

www.emperpep.deviantart.com

What is your inspiration?
My inspirations are from cute art and psychedelic style, I like rainbow color scheme and messy chaotic art composition, yet mathematically structured.

I also like manipulating nature creations into something weird and cute, like weird plants or weird creatures, also making them look nice and interesting at the same time.

What programs do you use to edit your works?
I use Paint Tool SAI, Adobe Photoshop, and Clip Studio Paint Pro.

¿Cual es tu inspiración?
Me inspiro en el arte cute de estilo psicodélico, me gustan los colores del arco iris y las composiciones desordenada, el arte caótico, pero matemáticamente estructurado.

También me gustan las creaciones inspiradas en la naturaleza, plantas raras, criaturas extrañas, todo con un estilo cute e interesante al mismo tiempo.

¿Que programas usas para editar tus trabajos?
Yo uso Paint Tool SAI, Adobe Photoshop, y Clip Studio Paint Pro.

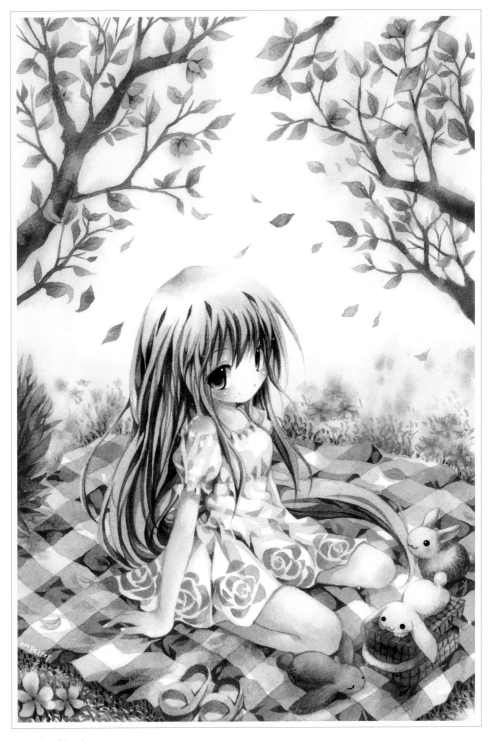

Bunnies Picnic

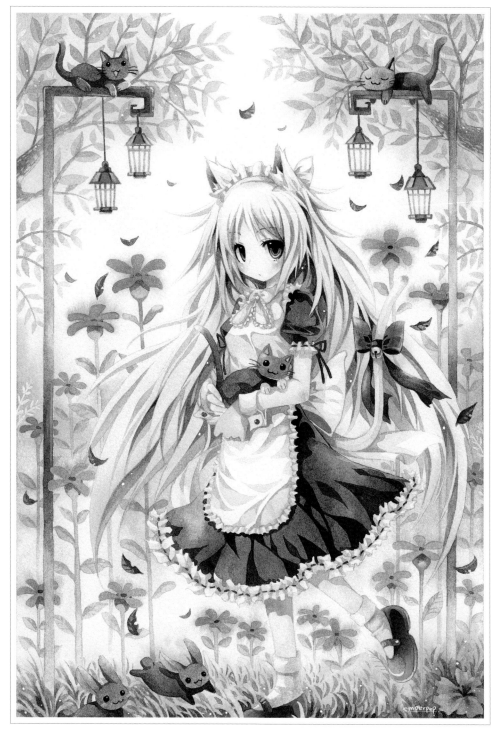

Catgirl Maid

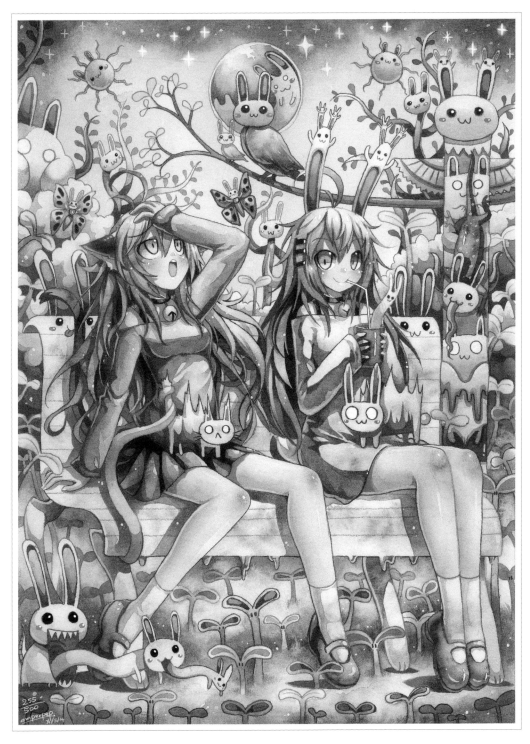

Dream of Leporiphobia

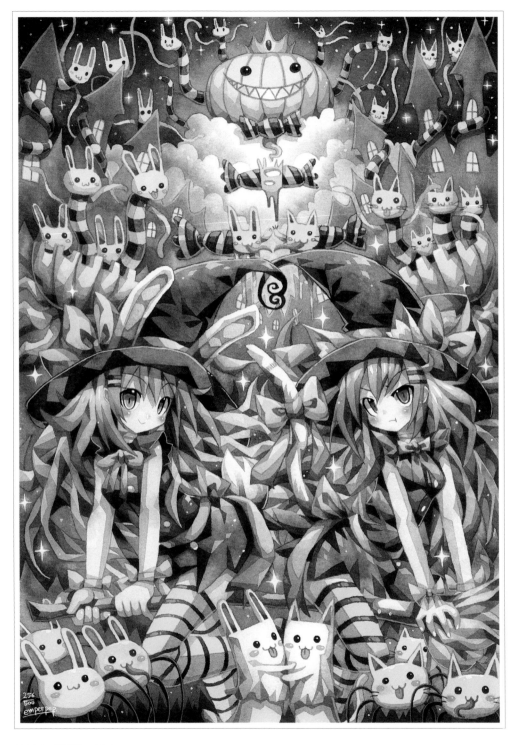

Happy Halloween

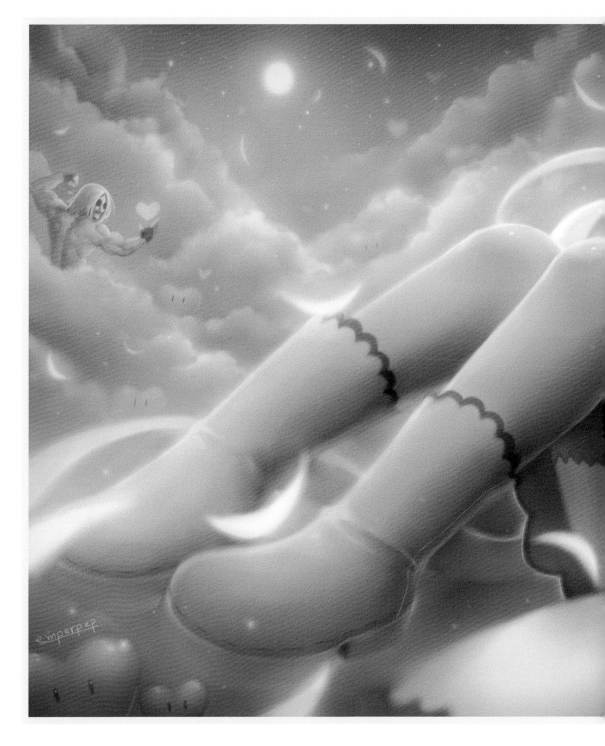

Happy Valentine

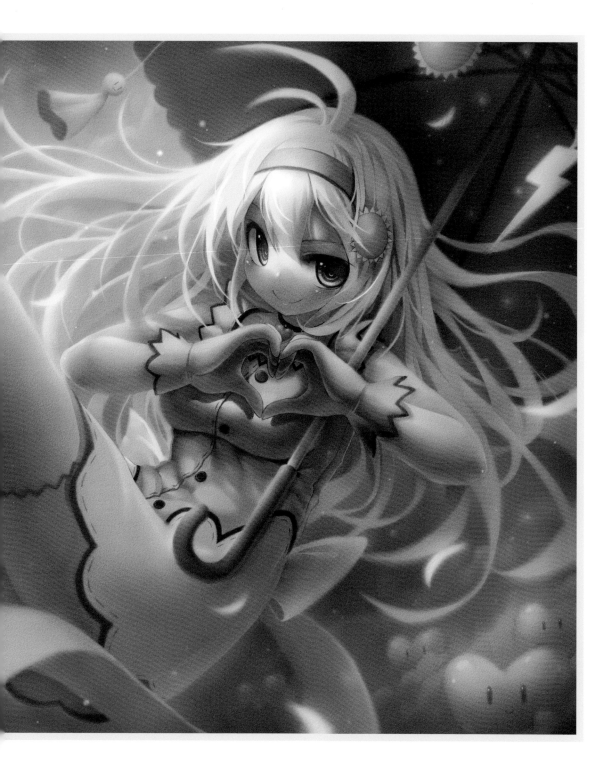

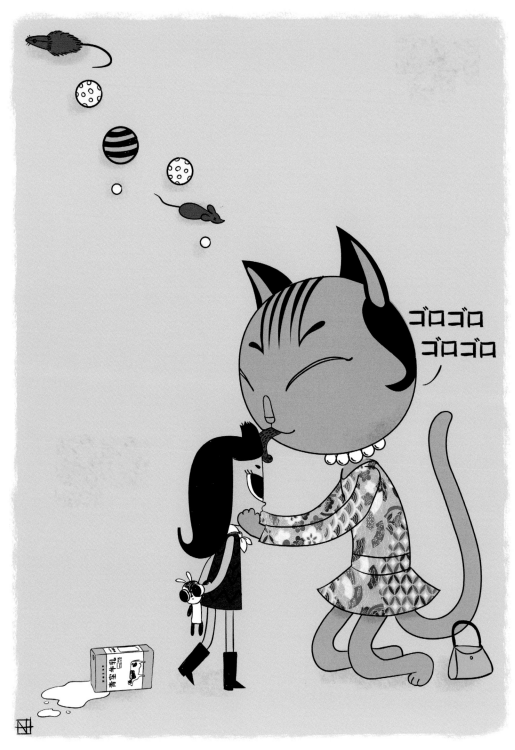

My parents, they're cats!

ANDREA INNOCENT

www.andreainnocent.com
www.otoshimono.org

What is your inspiration?
Whilst living in Japan I found myself seeing the world in a different way, almost like a child again. I quickly found that thinking in this new way and combining otherwise absurd pairings make for fun and interesting images and stories.

What programs do you use to edit your works?
I draw everything using a regular pencil, then I work it up in Adobe Illustrator and finish it off in Adobe Photoshop.

¿Cual es tu inspiración?
Cuando vivía en Japón empecé a ver el mundo de diferente manera, casi como un niño de nuevo. Rápidamente me di cuenta que verlo todo de esa nueva manera hacía que todo fuera más interesante y divertido.

¿Que programas usas para editar tus trabajos?
Dibujo todo usando un lápiz normal, después lo retoco con Adobe Illustrator y lo finalizo con Adobe Photoshop.

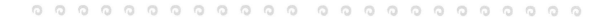

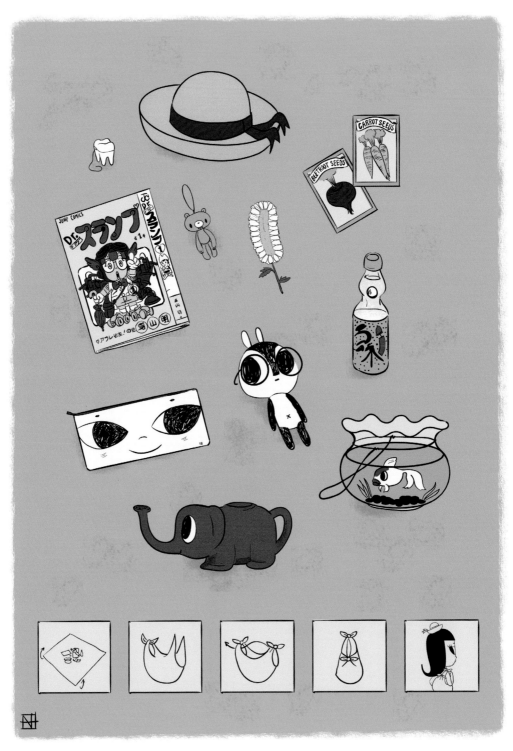

Important Things

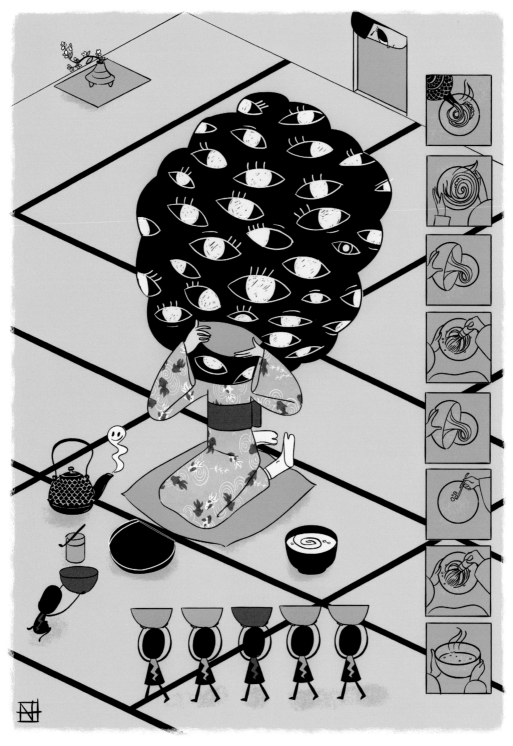

Pop!

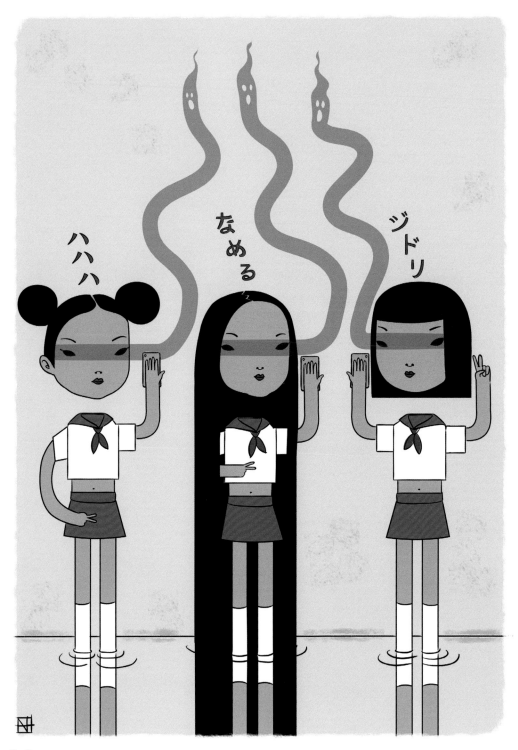

Selfies

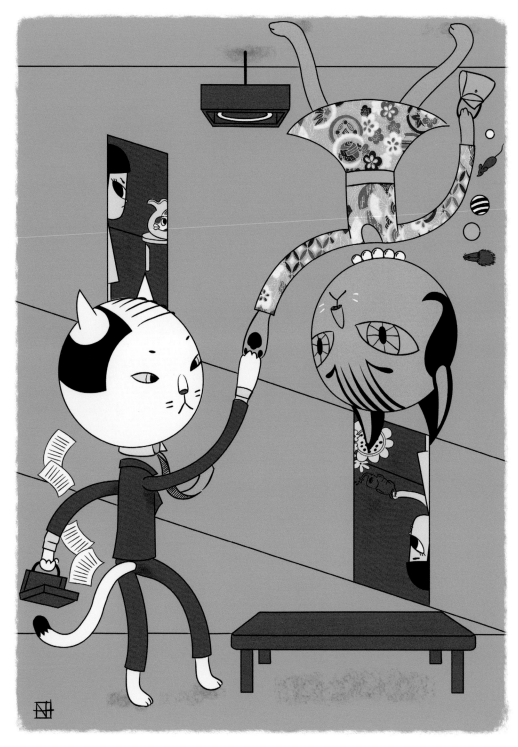

Noisy Parents

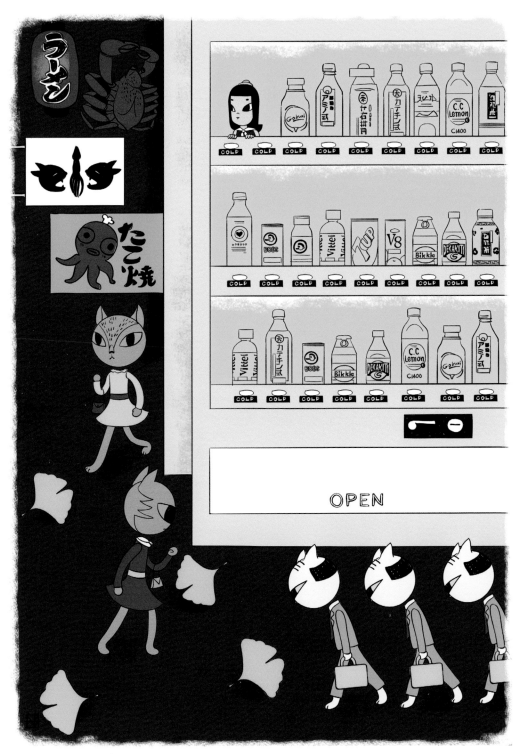

Small Village, Big City

Nofies

Selfies

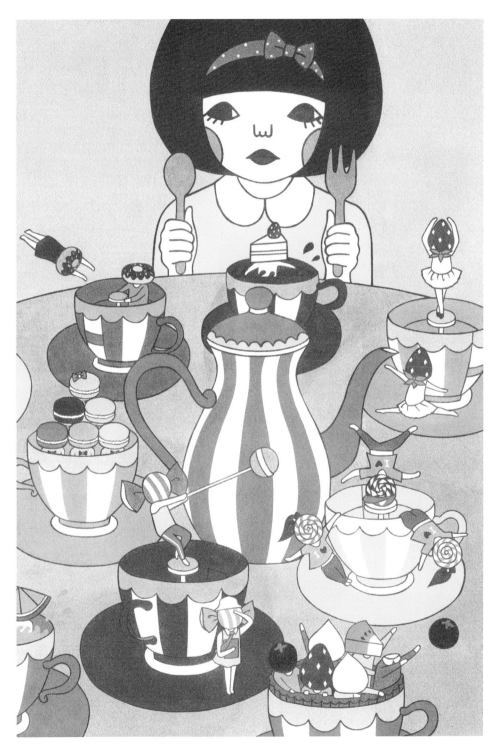

Sweets Time -Crazy Coffee Cup-

NAOSHI

www.nao-shi.com

What is your inspiration?
I always get inspirations from things around my everyday life, such as my favorite desserts, the rain, the big continuous sky, etc... My art is the reflection of my imagination. I usually get ideas and start sketching when I imagine surreal things and have a moment like "Ah, the whole scenery would be funnier if those things looked like this!"

What programs do you use to edit your works?
After I make a SUNAE (Sand Art), I spray it with water glue as a top coat for my Sunae. And then I scan it and use Adobe Photoshop to check the details of my artwork!

¿Cual es tu inspiración?
Siempre me inspiro en cosas alrededor de mi vida diaria, como mis postres favoritos, la lluvia, el cielo, etc... Mi arte es la reflexión de mi imaginación. Por lo general me vienen ideas que comienzo a dibujarlas y cuándo me imagino cosas surrealistas pienso: " Ah, todo el paisaje sería más divertido si las cosas fueran así!"

¿Que programas usas para editar tus trabajos?
Después de hacer SUNAE (arte con arena), lo rocío con agua como si fuera un abrigo. Luego lo verifico todo y uso Adobe Photoshop para comprobar los detalles del trabajo.

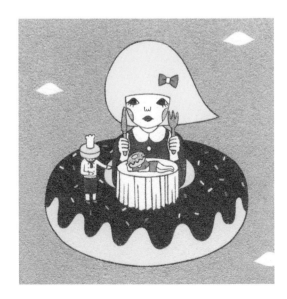

Doughnut Deinner

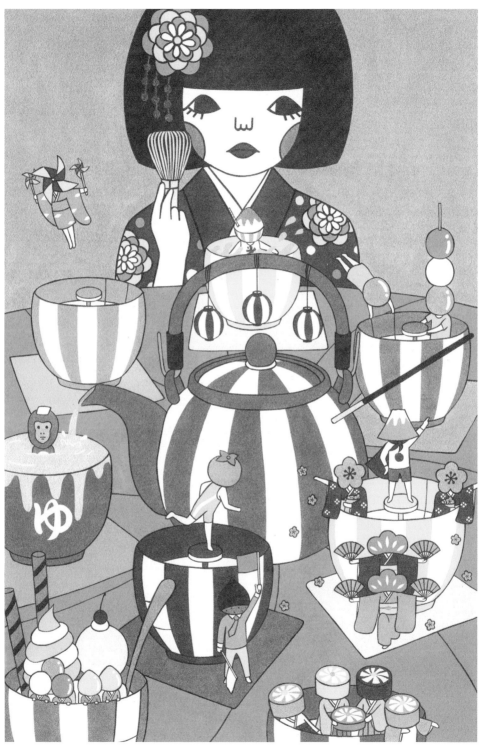

Tea Time -Crazy Teacup-

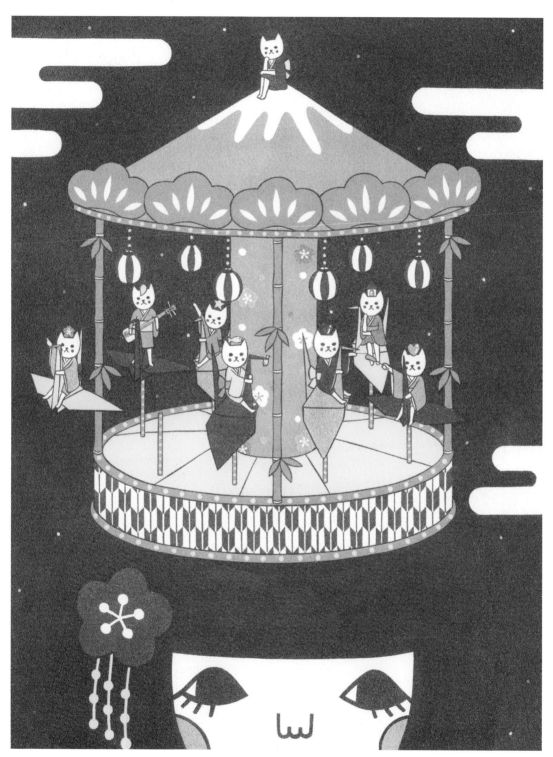

Delusional Merry-Go-Round -Endless Loop-

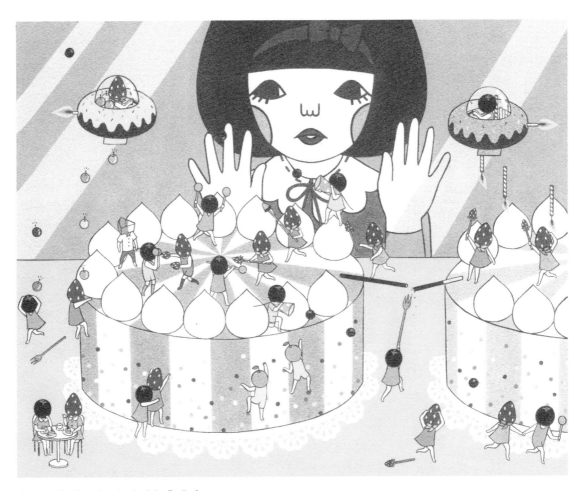

Cake's Battle -Unshakable Belief-

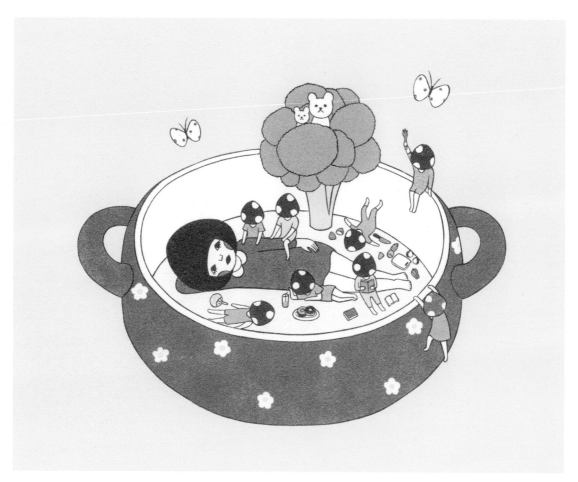

Stew pot -Day off of Mashroom-

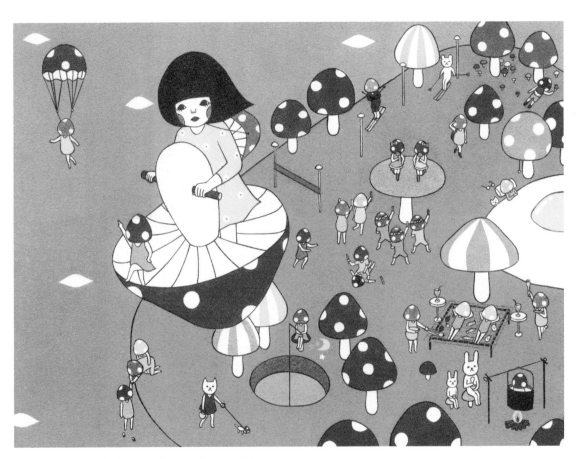

Mushroom Land -Escape to another world-

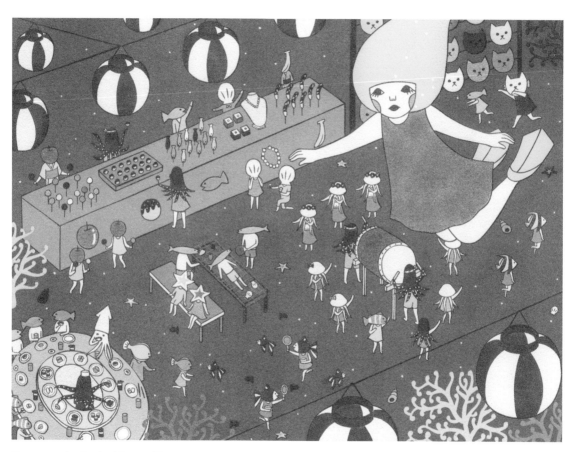

Summer festival -Happy Time-

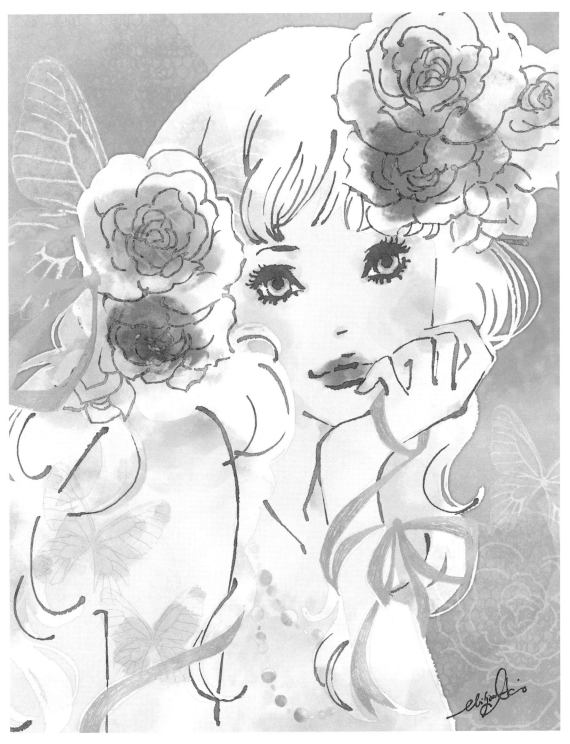

Roses

AKIRA EBIHARA

www.sugartoy.net

What is your inspiration?
I love Fashion models but also like beautiful scenery, such as seaside, forest, etc.

What programs do you use to edit your works?
I always use Adobe Photoshop for all my works.

¿Cual es tu inspiración?
Me encanta la moda, pero también los paisajes hermosos, como la playa, el bosque, etc.

¿Que programas usas para editar tus trabajos?
Siempre utilizo Adobe Photoshop para editar todos mis trabajos.

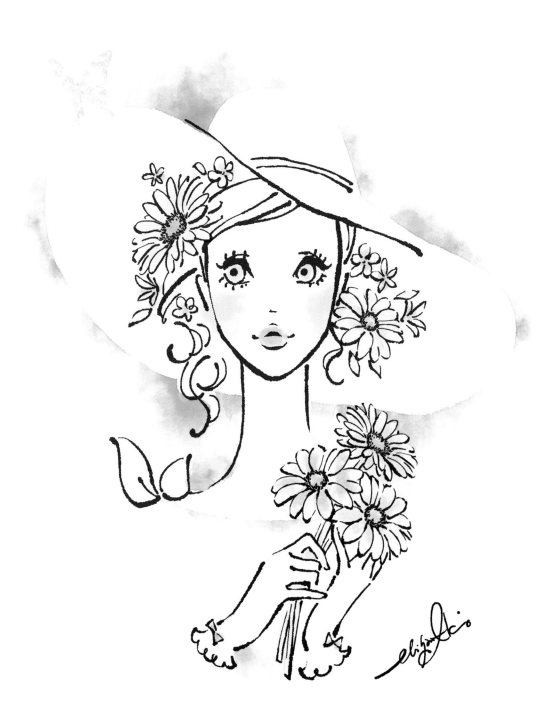

Miss Gerbera

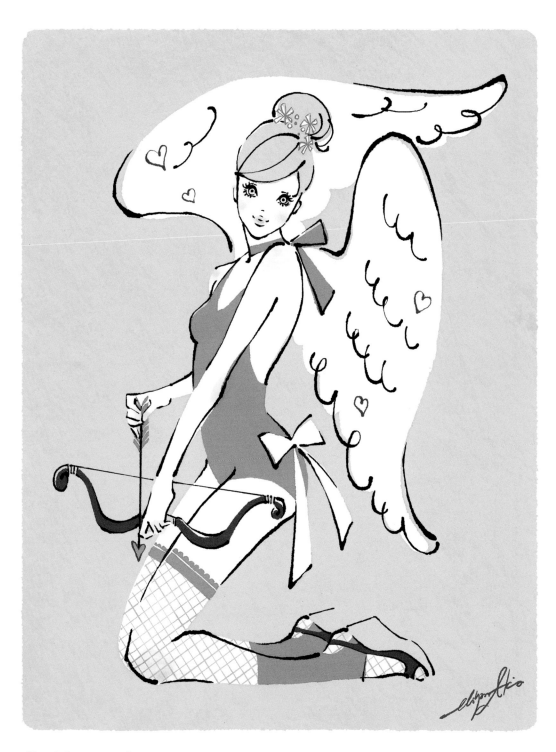

I'll catch you soon!

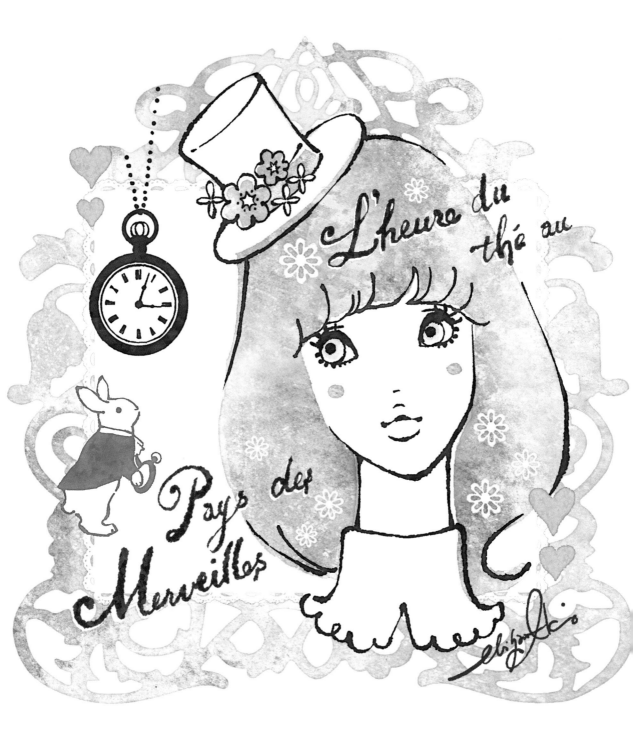

L'heure du thé au Pays des Merveilles

Alice's Adventures in Wonderland

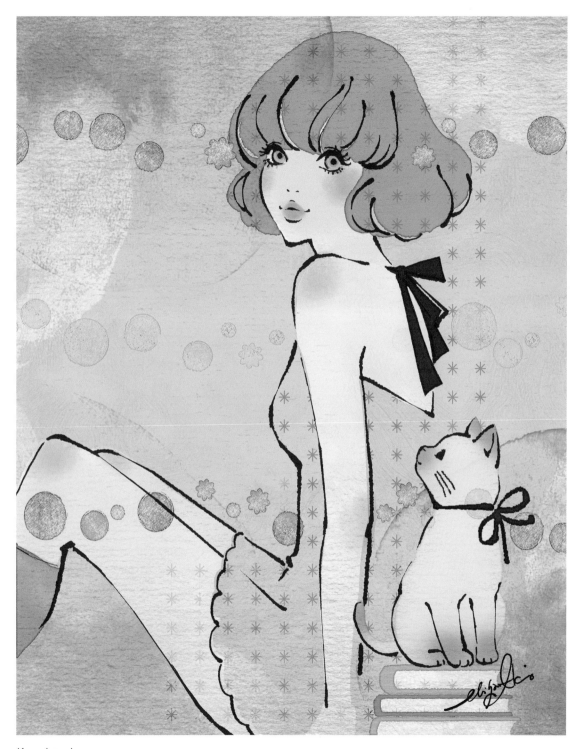

Koneko-chan

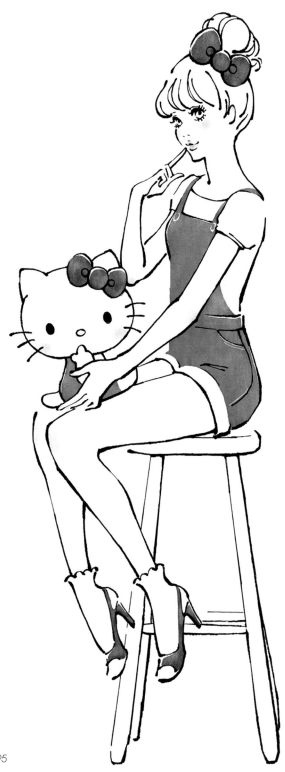

HelloKitty x AkiraEbihara

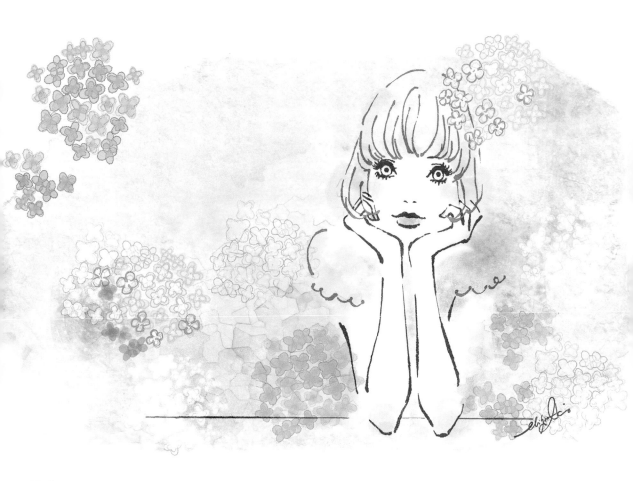

Hydrangeas

Following pages: *Nap*

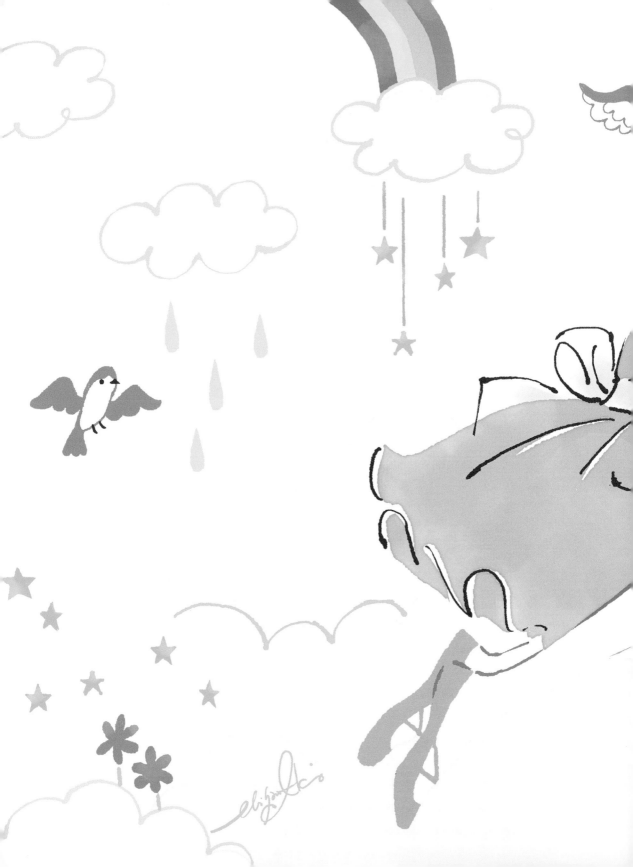

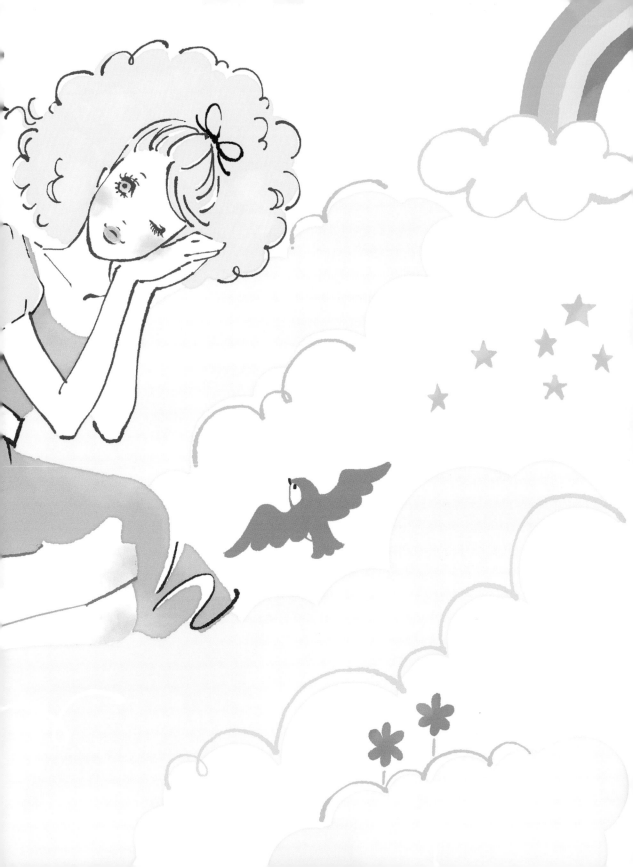

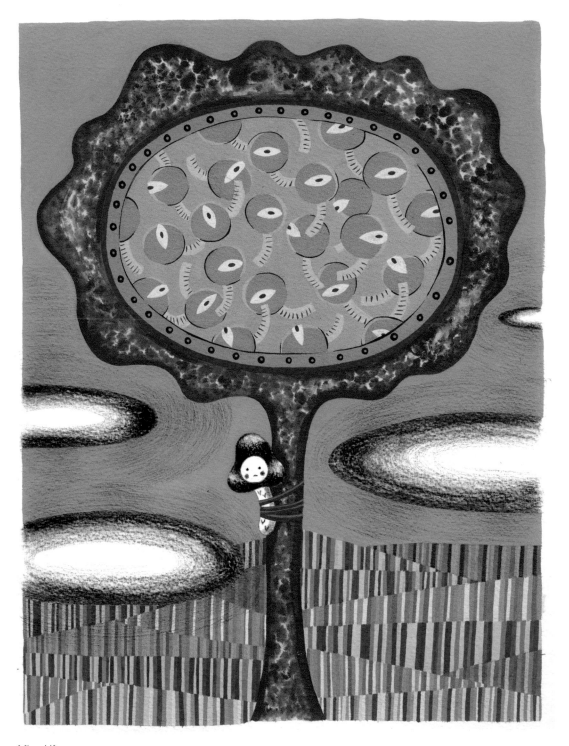

After Life

AYA KAKEDA

www.ayakakeda.com

What is your inspiration?
I get some great inspiration through traveling and
everyday life, I also like looking into different fabrics
and patterns from different culture.

What programs do you use to edit your works?
I use Adobe Photoshop.

¿Cual es tu inspiración?
Consigo inspiración a través de los viajes y el día
a día, también me gusta practicar con diferentes
estampados de culturas diversas.

¿Que programas usas para editar tus trabajos?
Me gusta usar Adobe Photoshop.

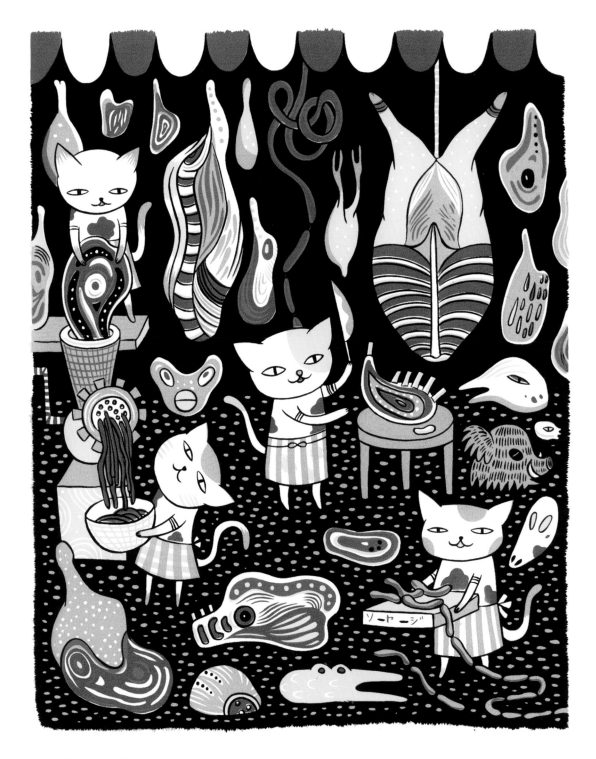

Cat Buttcher Purrfect

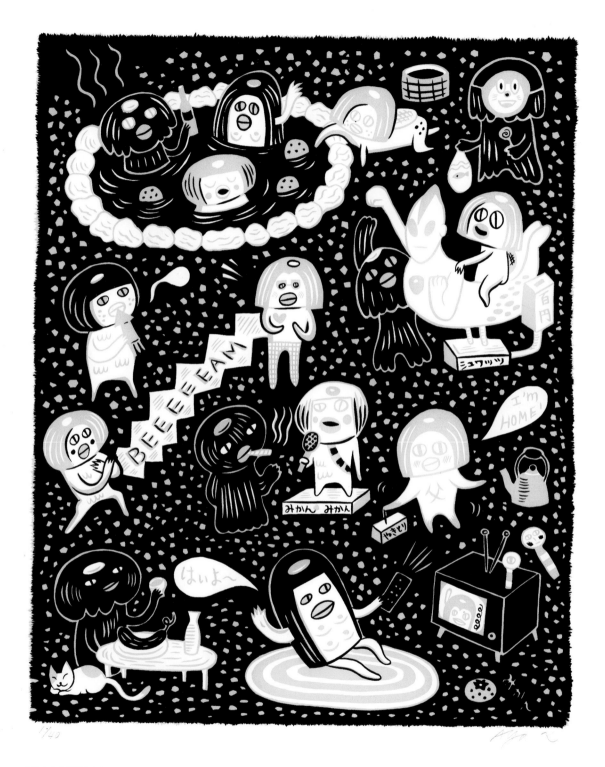

Kappa Village

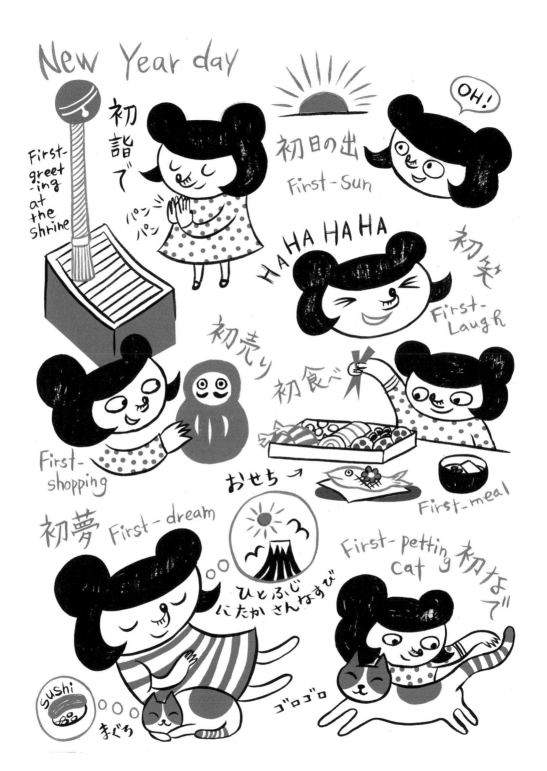

New Year Day

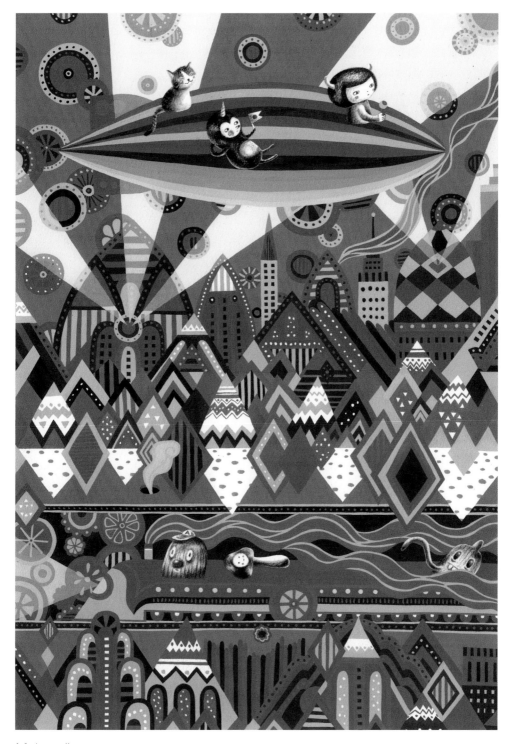

Metropolis

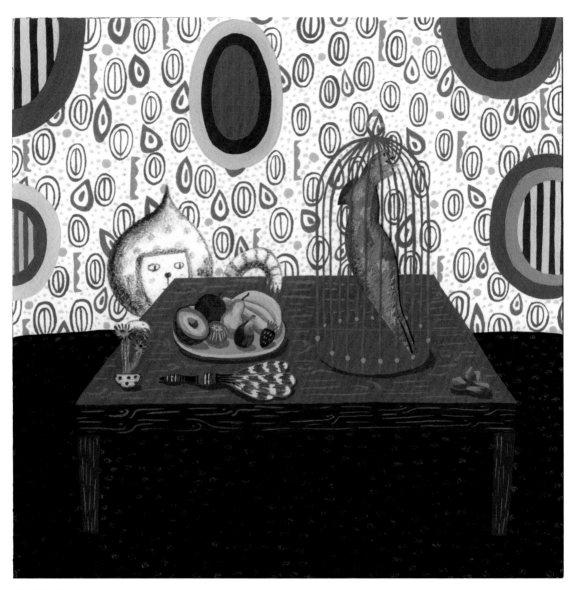

Fruit Robber

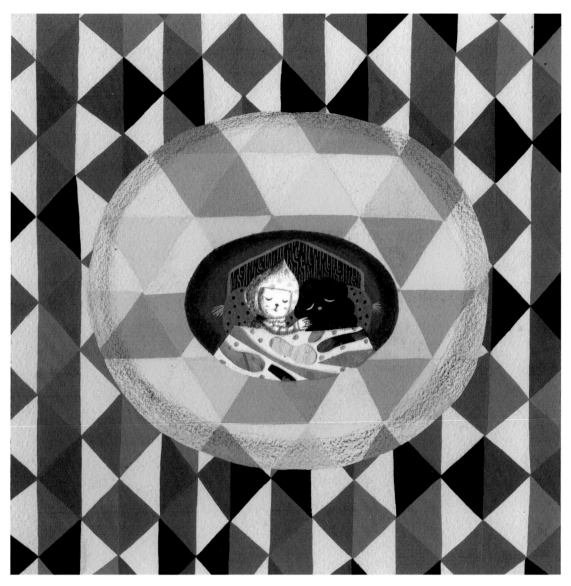

Sleeping

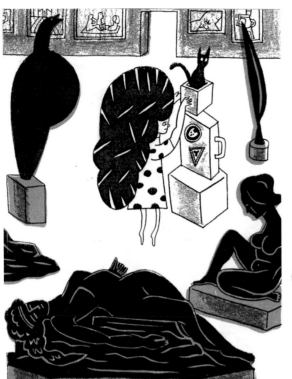

The Museum felt like a huge storage, she put a few boxes of her belongings on the main floor.

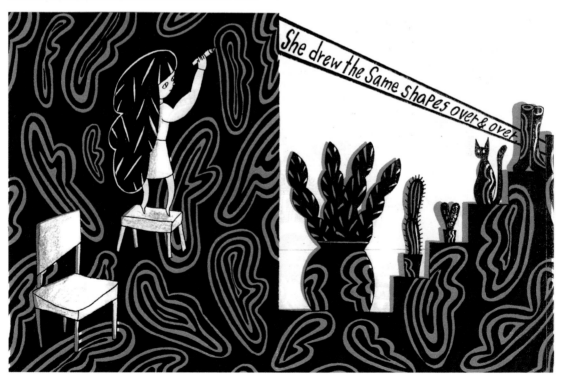

She drew the same shapes over & over

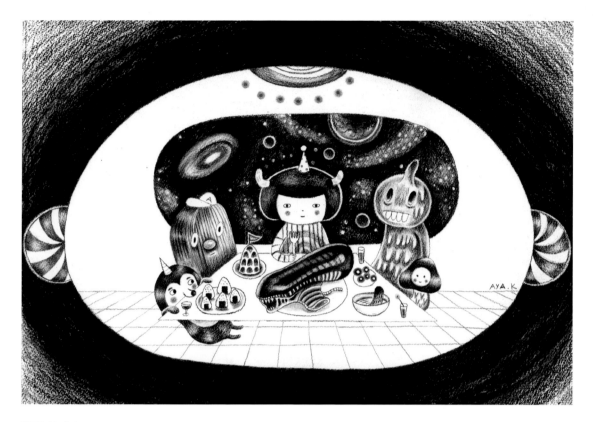

UFO Holiday

Left page *Page from a comic "Shape of things"*

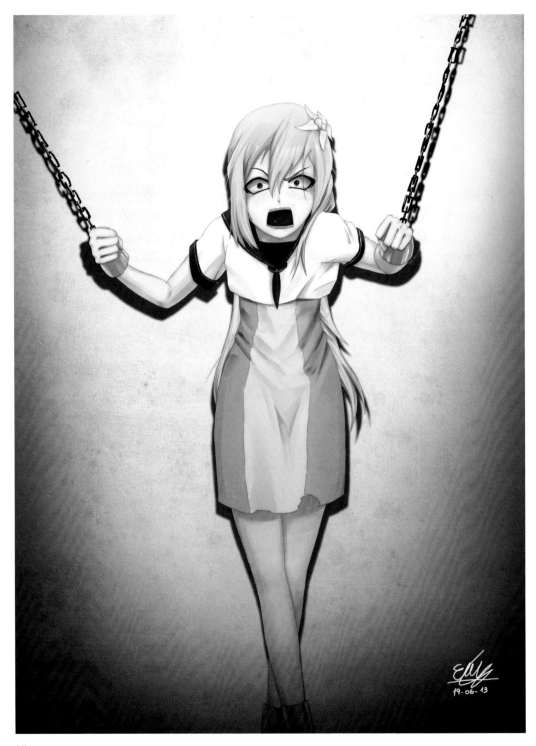

Lily

EZEQUIEL

www.yusepe.deviantart.com

What is your inspiration?
Thriller, mystery, bizarre, humoristic, confusing stories and over all, the mix of all the previous. In general these are the pieces of art that inspire me.

What programs do you use to edit your works?
For some time I used Paint Tool SAI. Now I use Adobe Photoshop.

¿Cual es tu inspiración?
Historias de suspense, de misterio, bizarras, humorísticas, confusas, y sobre todo mezclas de las anteriores. En general otras obras de arte son las que me inspiran.

¿Que programas usas para editar tus trabajos?
Durante un tiempo usé Paint Tool SAI. Ahora utilizo Adobe Photoshop.

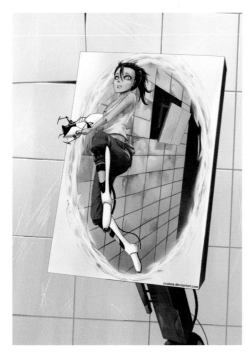

Chell

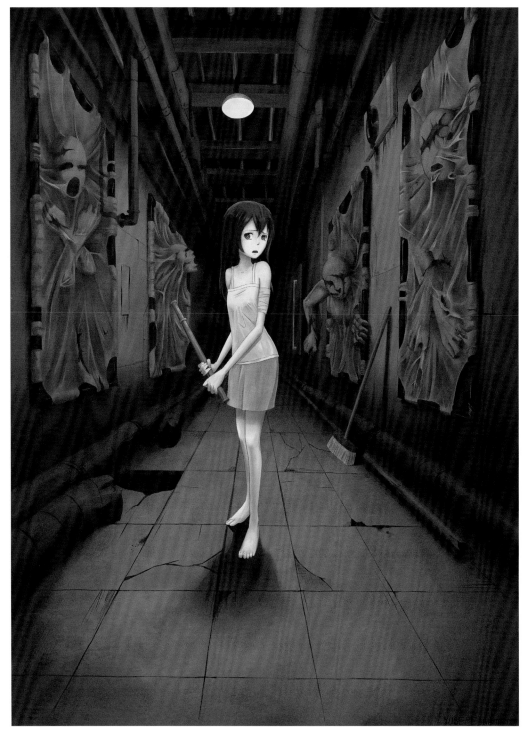

Halfway

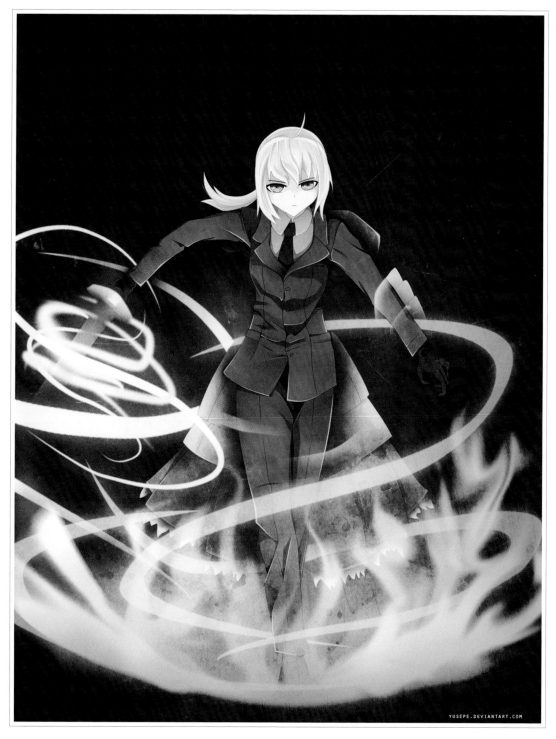

Saber

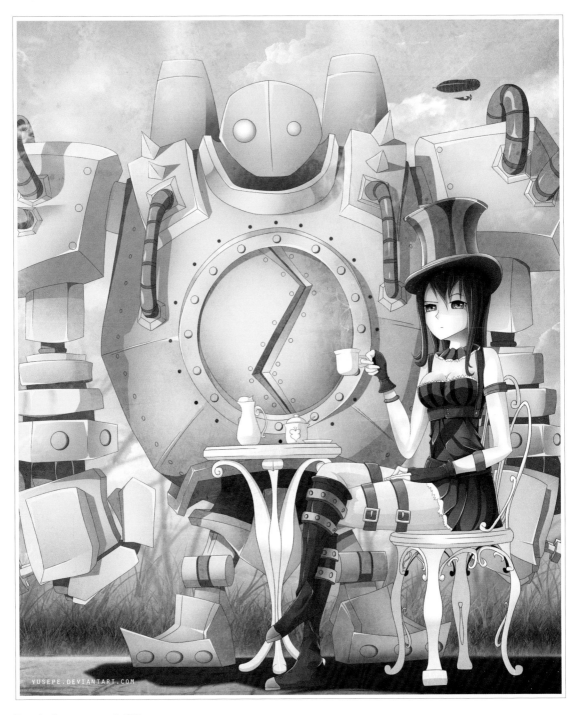

Tea in Summoner's Rift

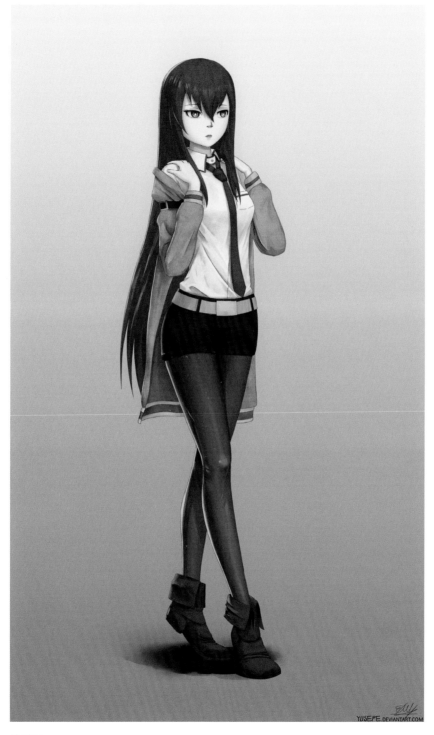

Kurisu

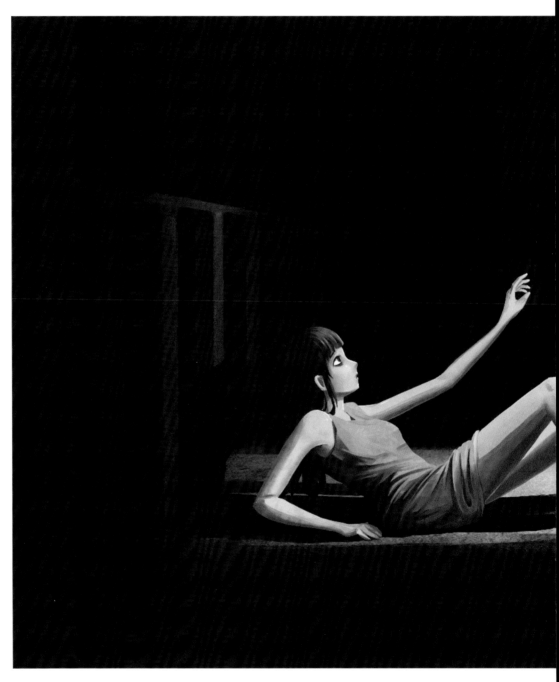

Mesmerizing Corridor

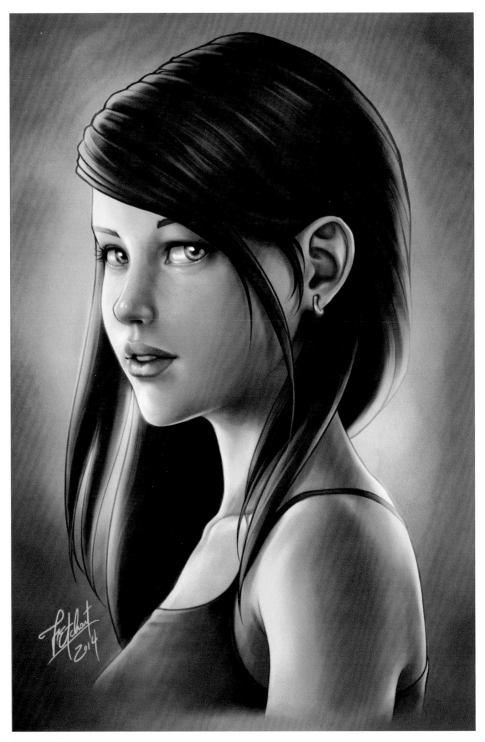

Miss Wolff

FRANCISCO ETCHART

www.franciscoetchart.deviantart.com

What is your inspiration?
Many of my works are "commissions", meaning a job that has been given to me. This way, references to the characters to draw are passed onto me with their particular characteristics or abilities. With that in mind, I try to structure a composition and to find the ideal spot to be able to show these characteristics. On the other hand, the illustrations are based on characters I like, or circumstances of them that I want to show... Always affording them my own drawing and colouring style.

What programs do you use to edit your works?
I generally draw by hand, with pencil or leadholder and paper. I also tend to use traditional technics to apply ink and markers to what regards paint. But to me, the most effective when it comes to do a job, it´s to keep on drawing with pencil and paper, the ink work and colours I do them digitally, entirely with Photoshop or Wacom digitalising tablet.

¿Cual es tu inspiración?
Muchos de mis trabajos son "commissions", es decir que son trabajos por encargo, de este modo me pasan referencias de los personajes a dibujar, con sus respectivas características o habilidades. Con eso en mente, trato de armar una composición y buscarle el punto ideal para poder mostrar esas características. Por otro lado, las ilustraciones propias están basadas en personajes que me gustan, o circunstancias que quiero mostrar de ellos... siempre brindándoles mi estilo propio de dibujo y coloreado.

¿Que programas usas para editar tus trabajos?
Generalmente dibujo a mano, con lápiz o portaminas y papel. También suelo entintar tradicionalmente y pintar con marcadores. Pero lo más efectivo para mi, cuando se trata de trabajos, es seguir dibujando con lápiz y papel, el entintado y los colores los hago digitalmente, enteramente con Photoshop y tableta digitalizadora Wacom.

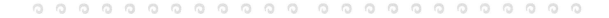

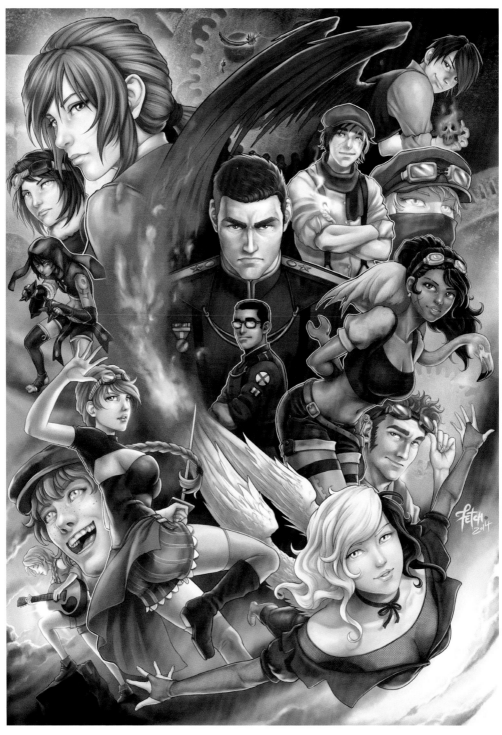

Lodan City of Gears

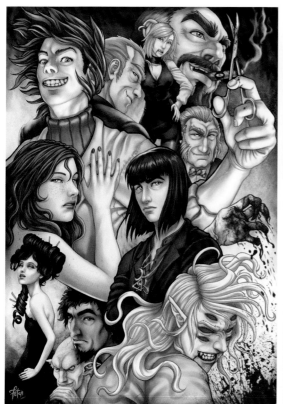

Vampires
The characters belong to Jenny Biggs & Sarah Brow"

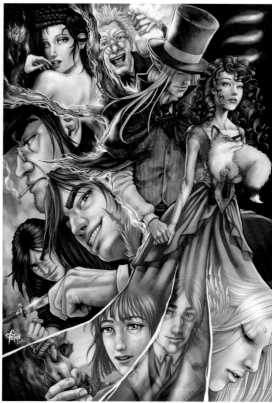

Victorians
The characters belong to Jenny Biggs & Sarah Brow"

Following pages: *The Melancholy of Miku*

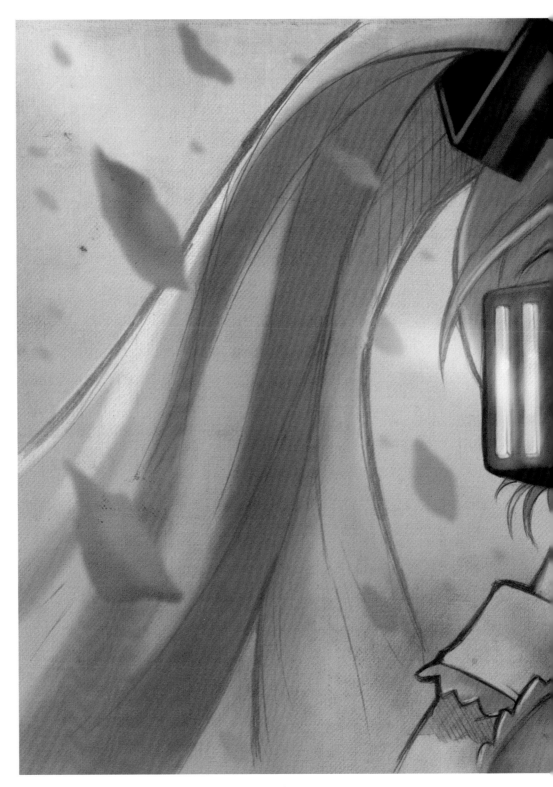

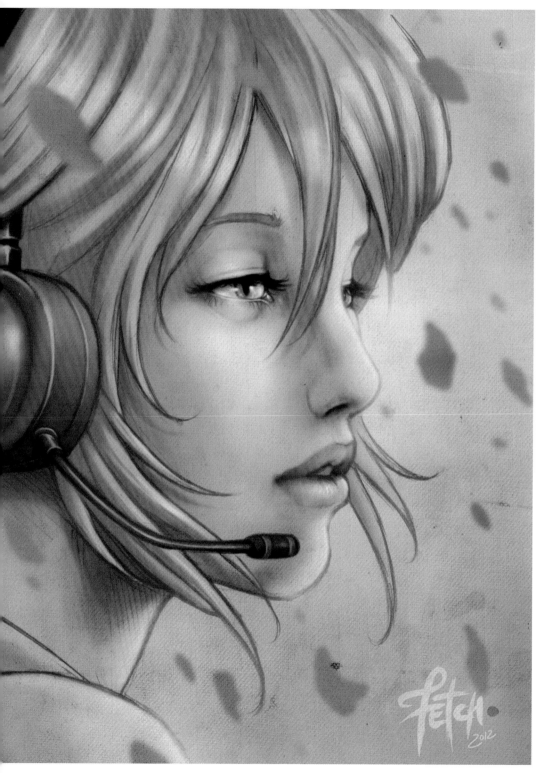

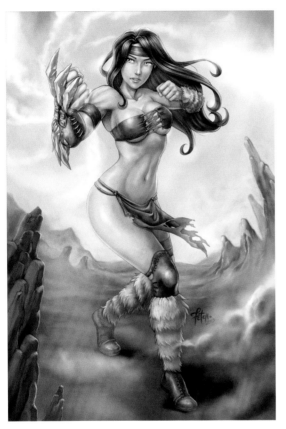

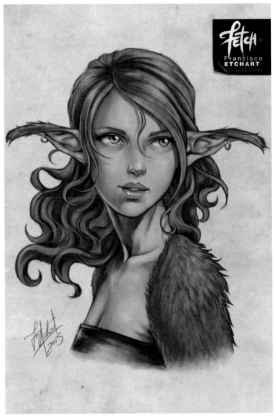

Floy

Valery

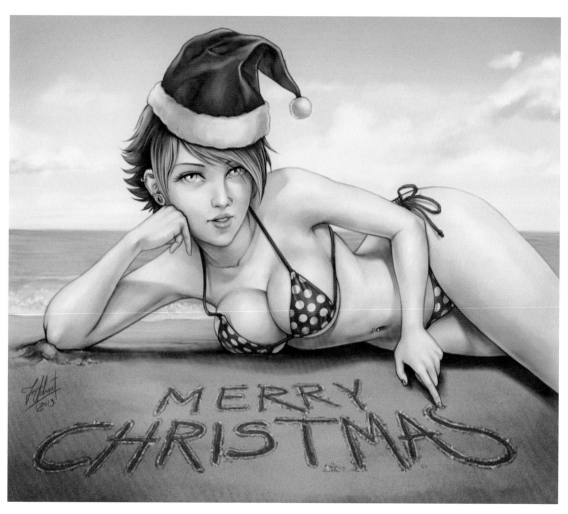

Xmas Pinup

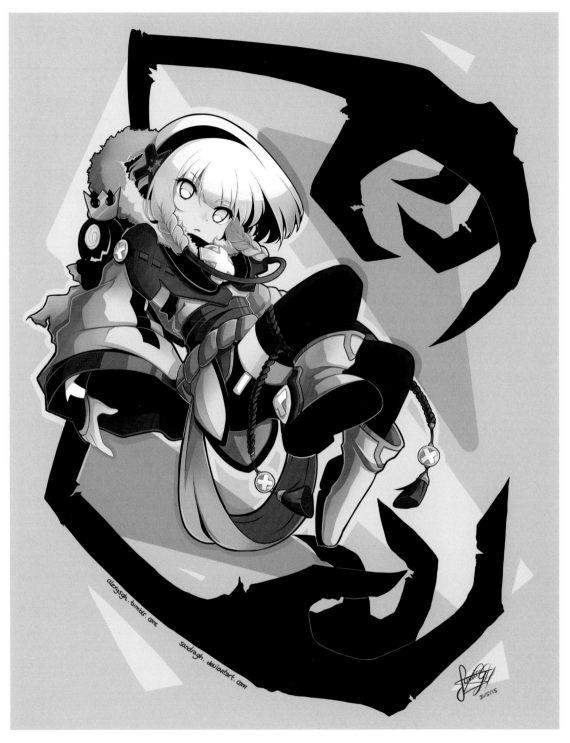

Mylett and Aleph

SANDRA G.H.

www.sandragh.deviantart.com

What is your inspiration?
I get much of my inspiration from the works of other artists. Music is also one of my main sources of inspiration

What programs do you use to edit your works?
The program I use to do my work is called Paint Tool SAI. I practically do the whole drawing with this program. I also use Photoshop CS5 to give it the final tweaks (filters, adjustment layers...).

¿Cual es tu inspiración?
Me inspiro mucho en trabajos de otros artistas, también la música es una de mis fuentes principales de inspiración.

¿Que programas usas para editar tus trabajos?
El programa que utilizo para realizar mis trabajos se llama Paint Tool SAI, con este programa hago prácticamente todo el dibujo. También utilizo Photoshop CS5 para darle los retoques finales (filtros, capas de ajuste...).

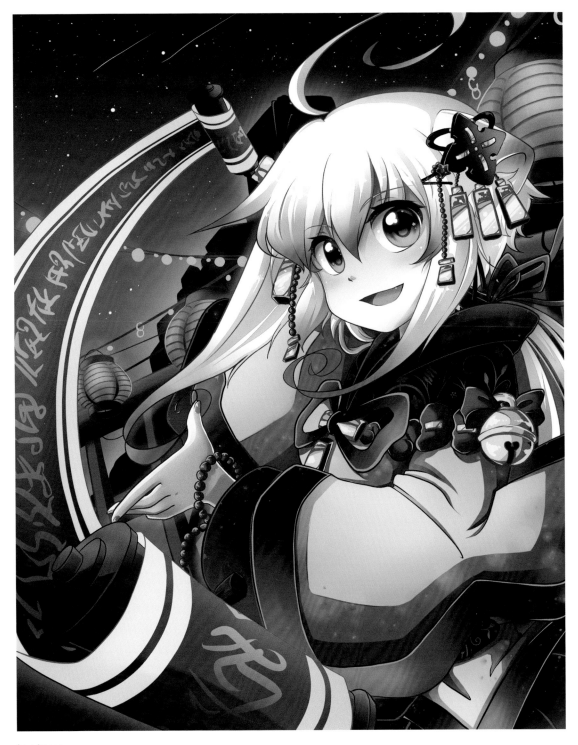

Lanterns

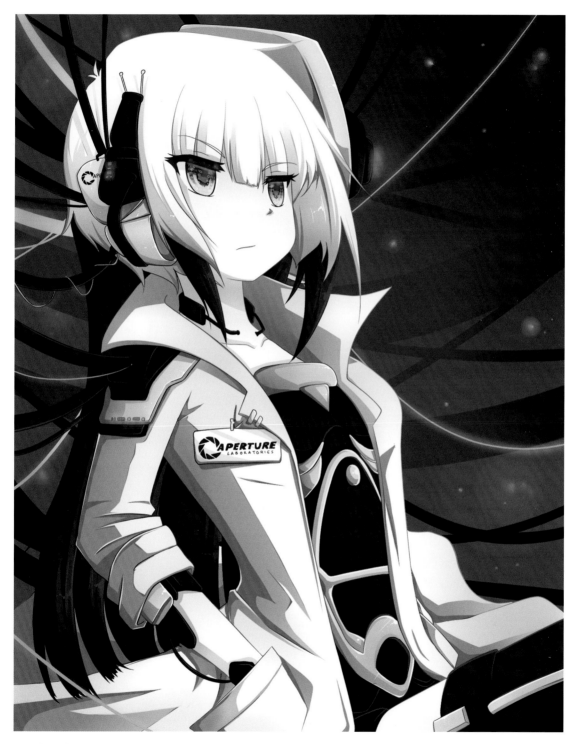

Leader Machine

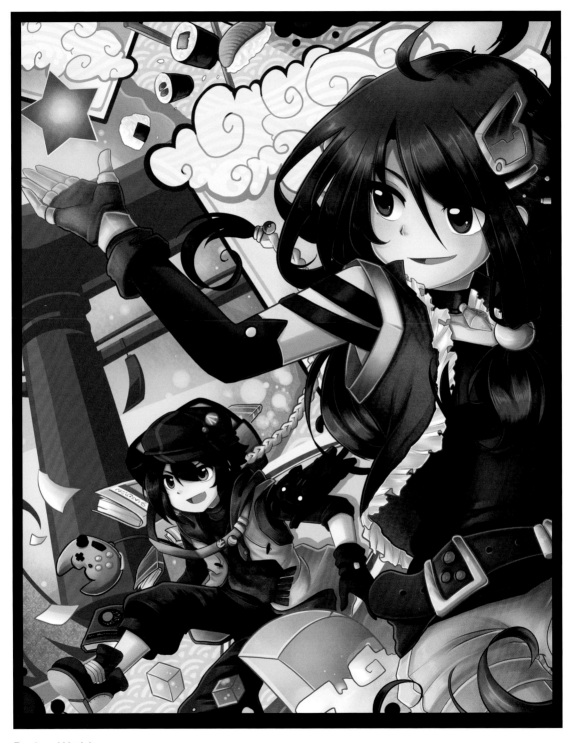

Fantasy World

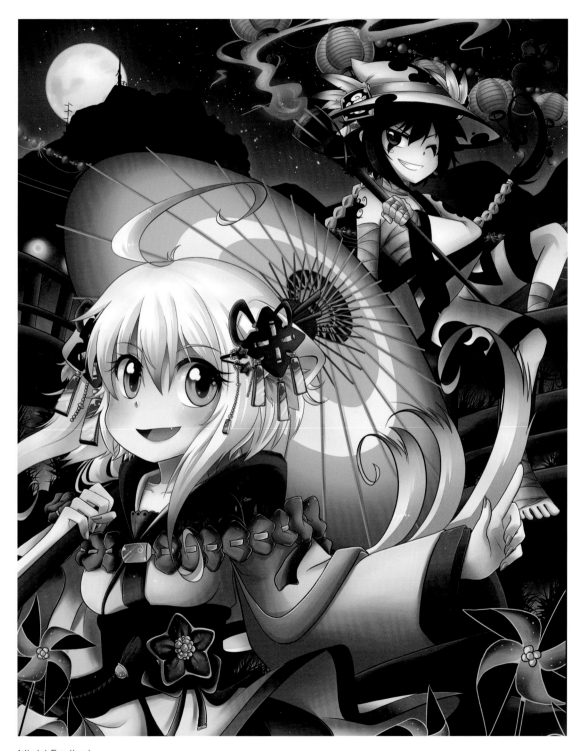

Night Festival

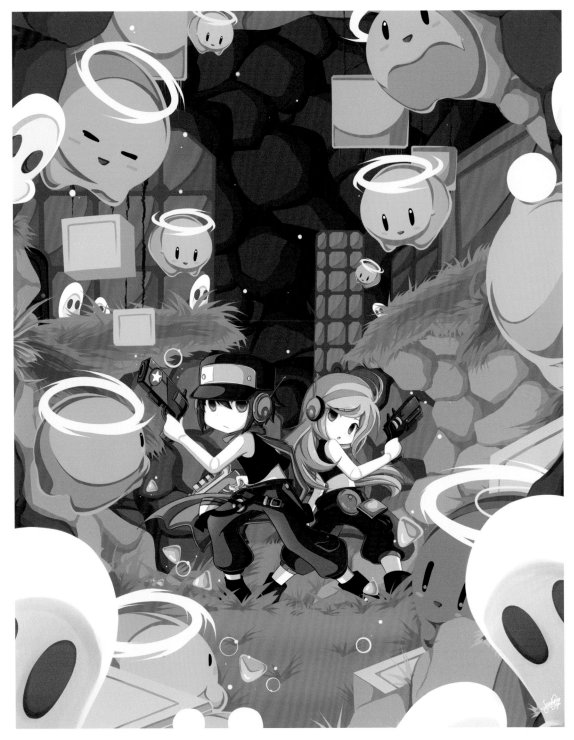

Cave Fight

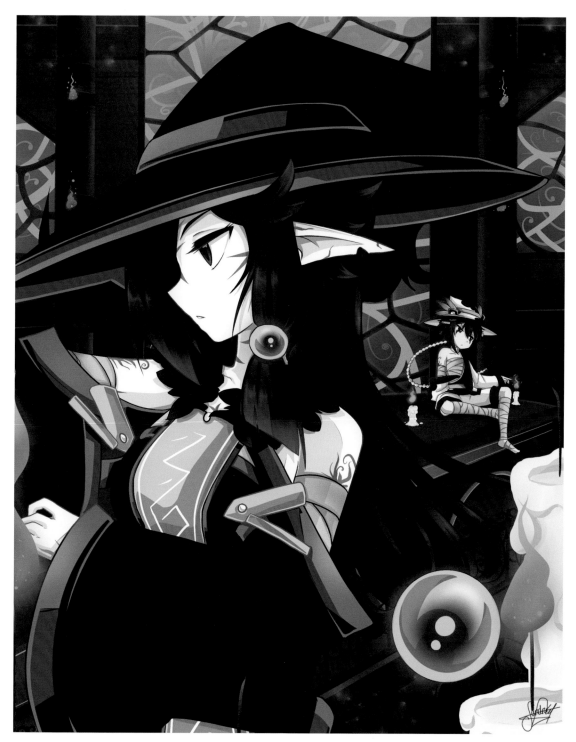

Blue Temple

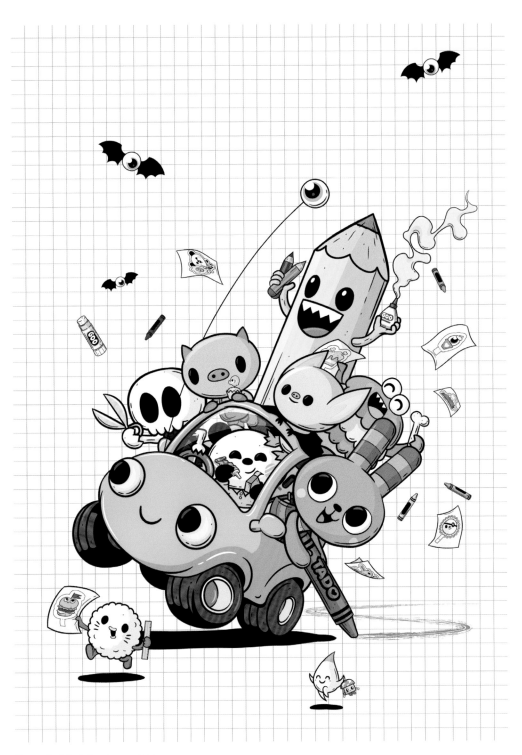

Doodle Mobile (Canon Asia)

TADO

www.tado.co.uk

What is your inspiration?
Our inspiration comes from all kinds of places - a lot of references from our travels to strange parts of the globe, classic cartoons, our adventures in food, vintage toys and comics, tiny vehicles and a huge amount from each other too!
We really enjoy bouncing ideas back and forth between us. This is where most of our ideas come from - our shared and warped inspirations.

What programs do you use to edit your works?
We use a combination of Adobe Ilustrator and Adobe Photoshop for most of our work.

¿Cual es tu inspiración?
Nuestra inspiración viene de todo tipo de lugares, de viajes a las partes mas remotas de la tierra, de historias clásicas, de nuestras aventuras con alimentos, juguetes vintage, comics, y vehículos en miniatura! Realmente disfrutamos compartiendo ideas de aquí y de allá entre nosotros. Esto es de donde la mayor parte de nuestras ideas vienen, de nuestras inspiraciones compartidas.

¿Que programas usas para editar tus trabajos?
Utilizamos una combinación de Adobe Ilustrador y Adobe Photoshop para la mayor parte de nuestros trabajos.

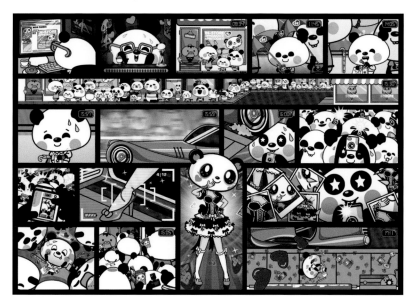

Pandaotaku Comic

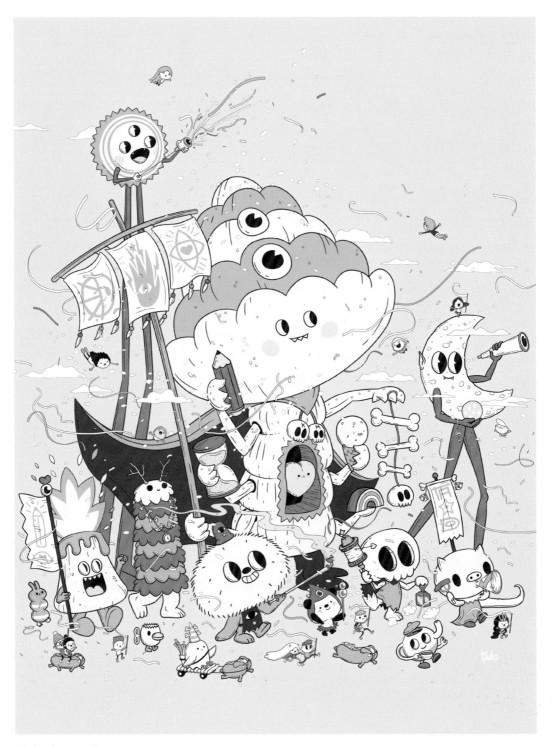

Pictoplasma Shaman

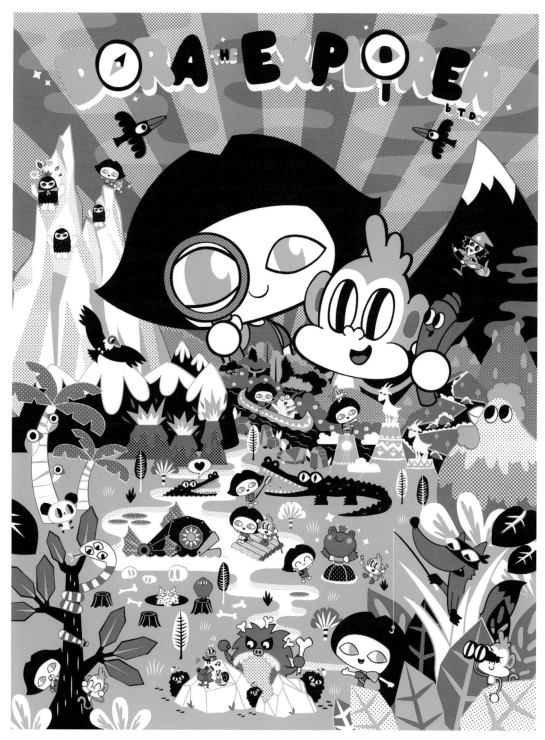

Dora The Explorer (Nickelodeon)

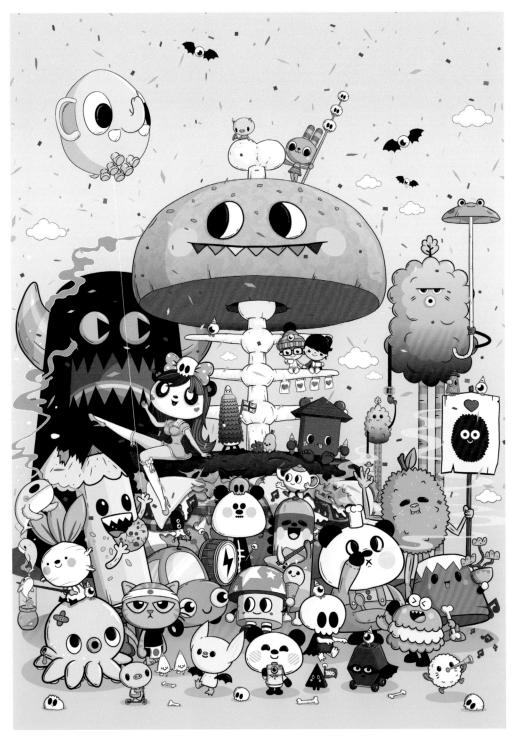

TADO-Party (Canon Asia)

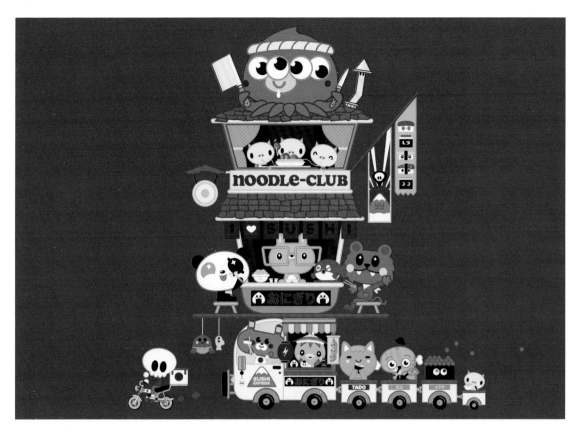

Sushi Express

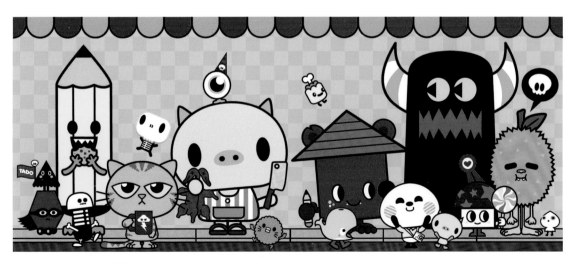

JapanLA x Mighty Wallet

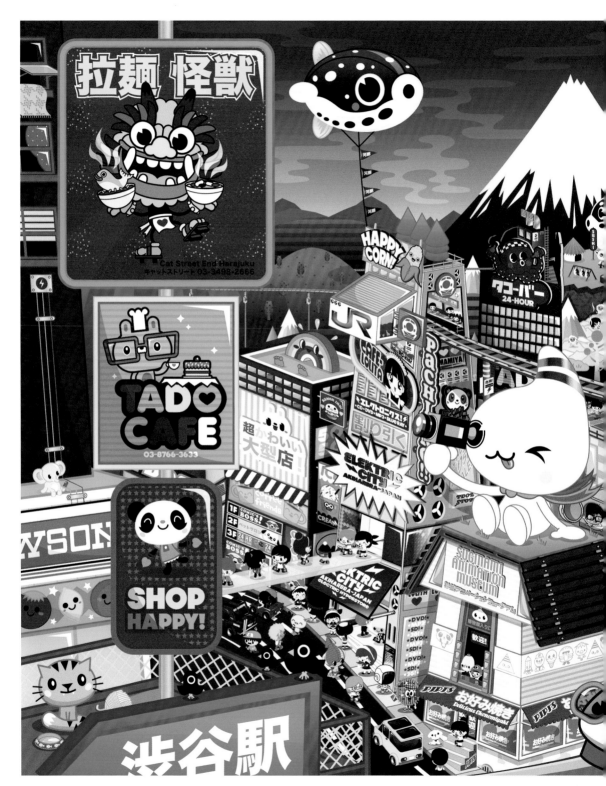

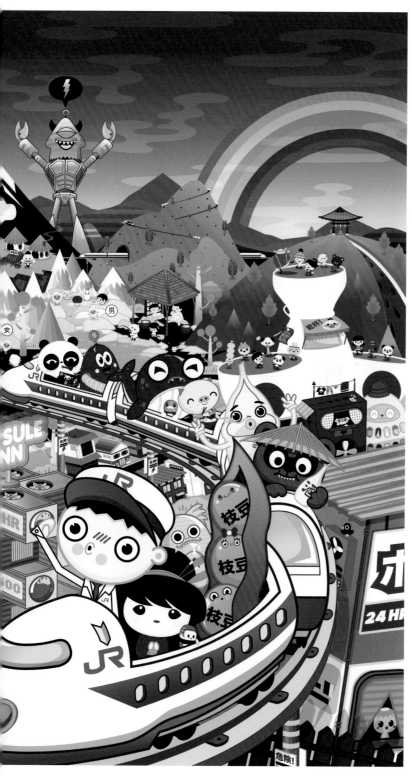

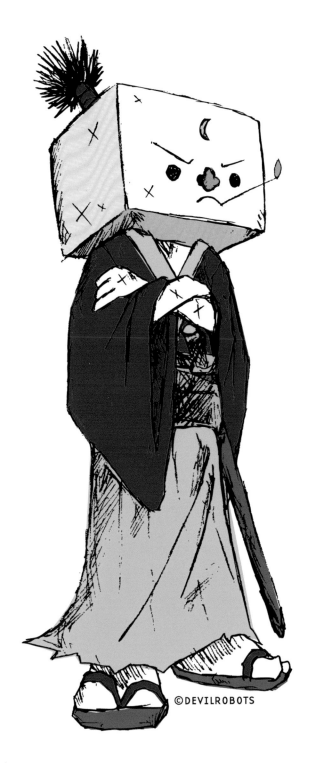

Samurai To-fu

DEVILROBOTS

www.dvrb.jp

What is your inspiration?
My main inspiration is daily life: People, toys, movies, magazines, fashion. food, comics, etc.

What programs do you use to edit your works?
I use Adobe Illustration & Adobe Photoshop.

¿Cual es tu inspiración?
Mi inspiración principal es la vida en general: La gente, los juguetes, películas, revistas, comida, comics...

¿Que programas usas para editar tus trabajos?
Utilizo Adobe Illustration y Adobe Photoshop.

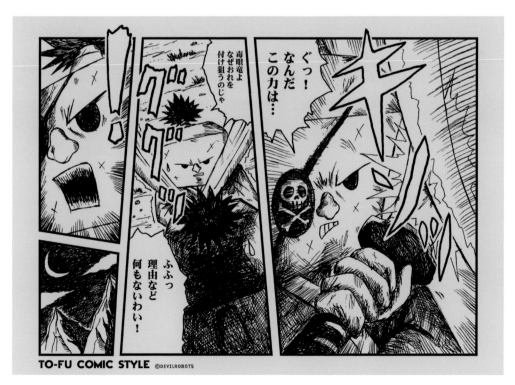

To-Fu Style

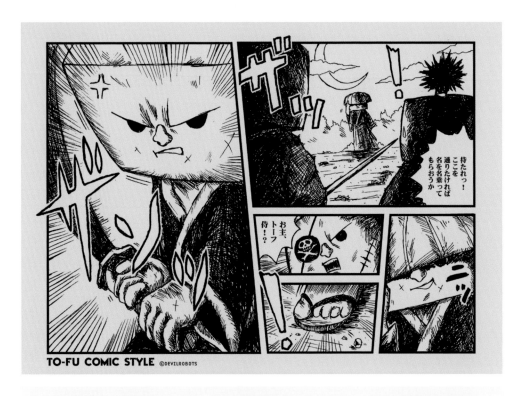

TO-FU COMIC STYLE @DEVILROBOTS

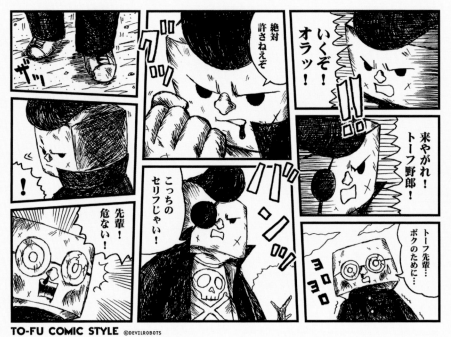

TO-FU COMIC STYLE @DEVILROBOTS

To-Fu Style

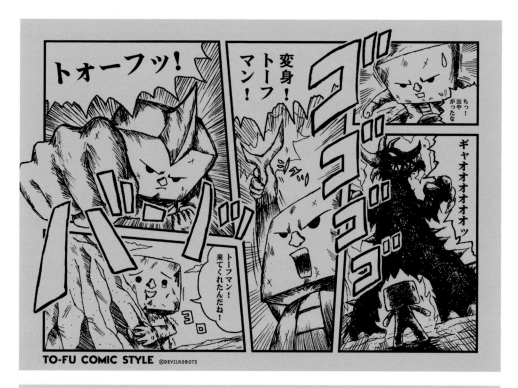

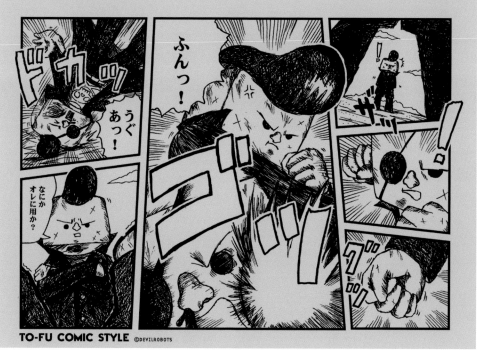

To-Fu Style

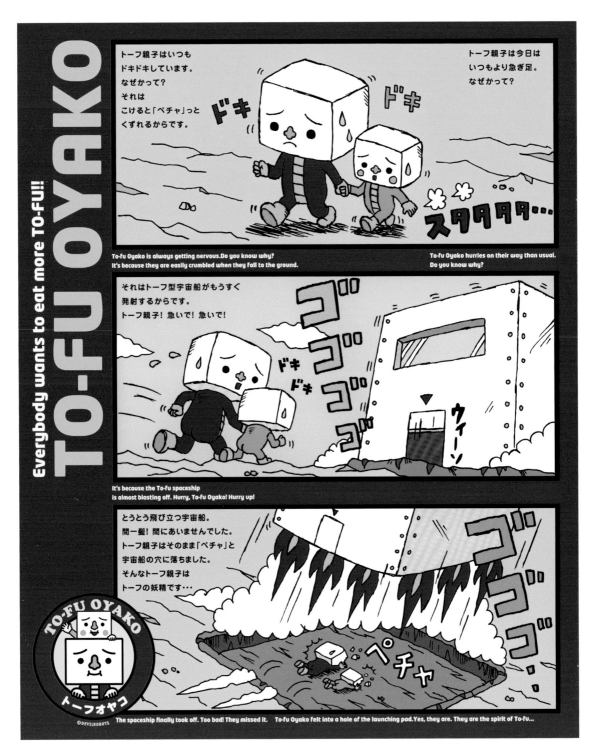

To-Fu Oyako Comic

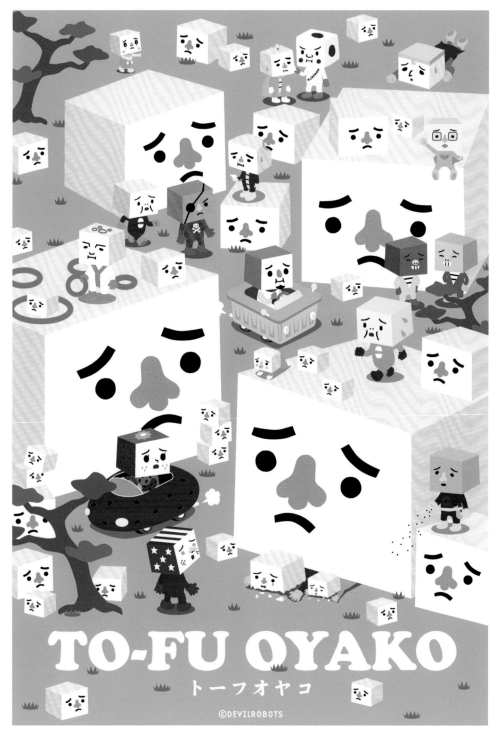

To-Fu Oyako

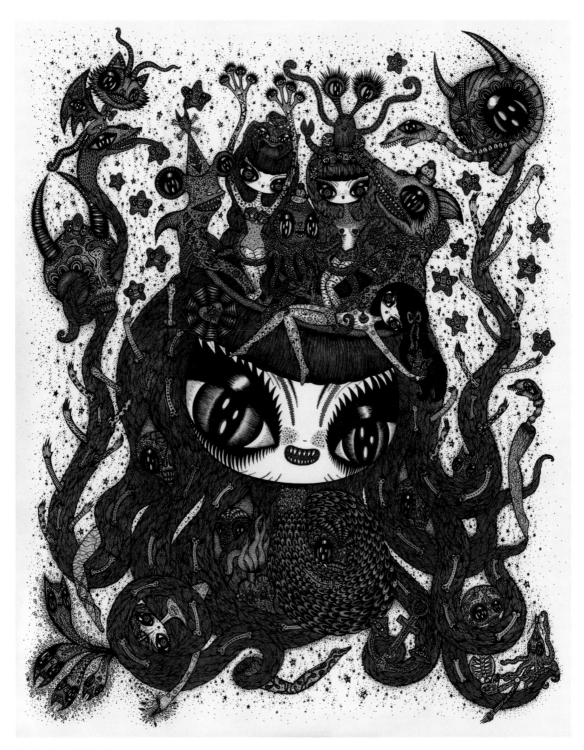

Brain Beach Party

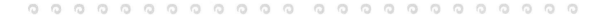

CIOU

www.ciou.eu

What is your inspiration?

My inspiration comes from different cultures, countries and Nature. I am really inspired by everything I see in a natural history museum, botanical garden and even my little garden. I really like the baroque, rococo, decorative art in Europe. Also I am really inspired by the Japanese Yokai, the traditional Japanese culture and art, Asian art, American 30's to 50 's posters , psychedelic art, paganism, dark art. I love tattoo, manga, comics, American vintage toys, Japanese toys, vintage squeaky toys. I am a toy collector and they are one of my biggest inspiration day after day.

What programs do you use to edit your works?

I don't use any program to create my artwork, I love physical material. I love to use acrylic, gouache and ink. I also use mixed media technic, the base of my paintings is a collage which comes from a vintage dictionary and natural history books. I also love the screen printing technics and letter press printing.
The only program I use to edit,screen printings and books is Adobe Photoshop.

¿Cual es tu inspiración?

Mi inspiración viene de diferentes países y culturas. Realmente estoy inspirado por todo aquello que veo en un museo de historia natural, jardín botánico, o incluso en mi pequeño jardín. También me gusta el barroco, el arte rococó, y la arquitectura en Europa. Además me encanta la cultura tradicional japonesa, el arte asiático, carteles americanos de los años 50, lo psicodélico, el paganismo, el arte oscuro. Me gusta el tatuaje, el manga, las tiras cómicas, los juguetes americanos vintage, juguetes japoneses... Soy coleccionista de toys y ellos son una de mis mayores inspiraciones.

¿Que programas usas para editar tus trabajos?

No uso ningún programa para crear mi trabajo, me gusta el material físico. Suelo usar acrílico, gouache y tinta. La base de mis pinturas es la mezcla de un diccionario vintage y libros de historia natural. También me gustan las obras impresas. El único programa que a veces utilizo para corregir es Adobe Photoshop.

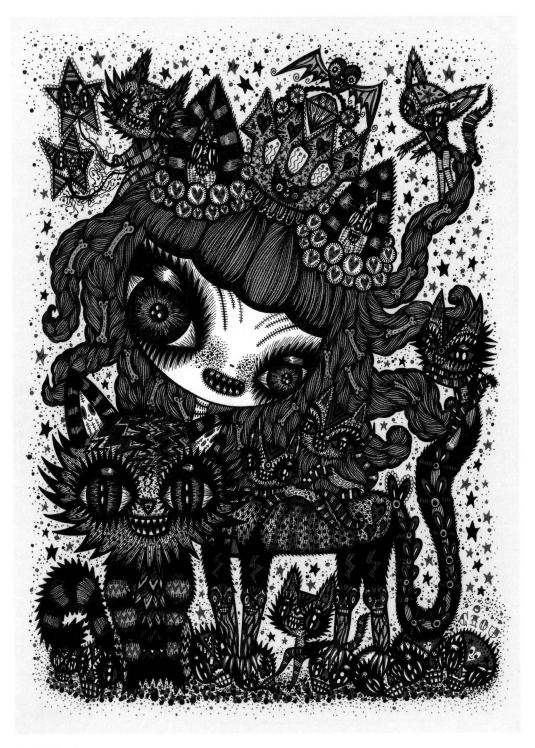

Cat's Family

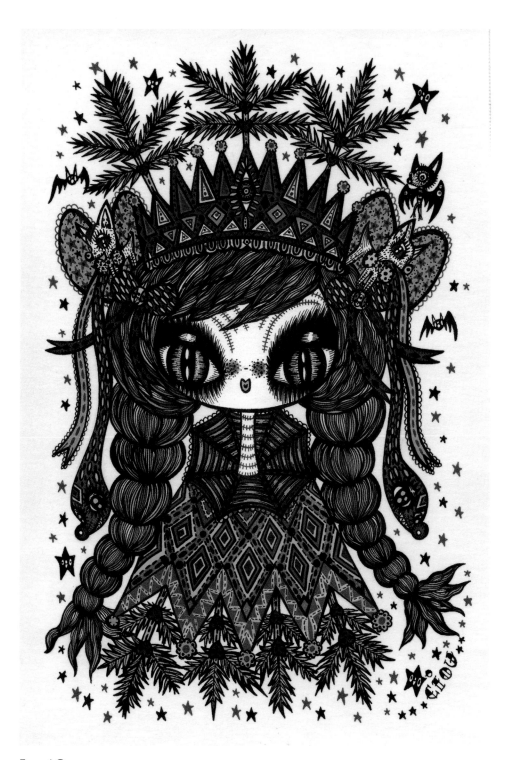

Forest Queen

Monster of the Rebirth

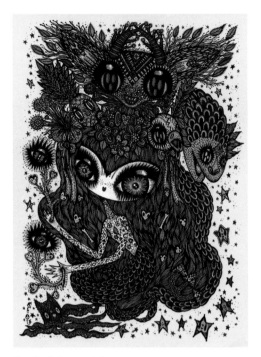

Exotic Mermaid

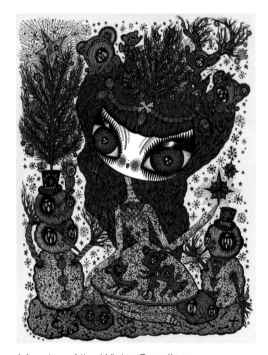

Monster of the Winter Greetings

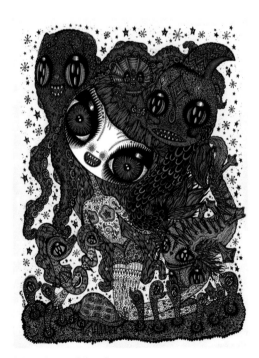

Monsters of the Sea

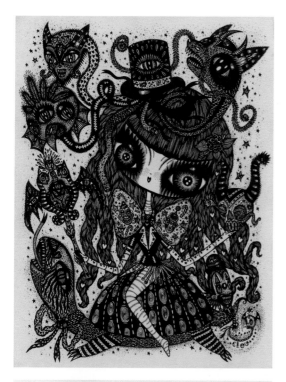

Skull Spell

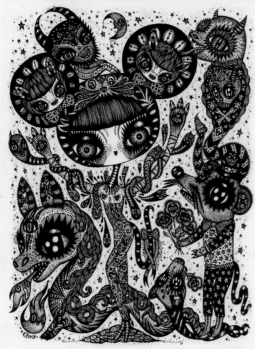

The Terrific Mouse Club

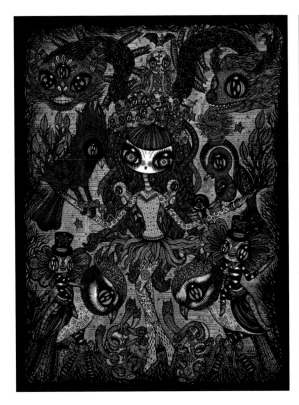

Bird's Paradise

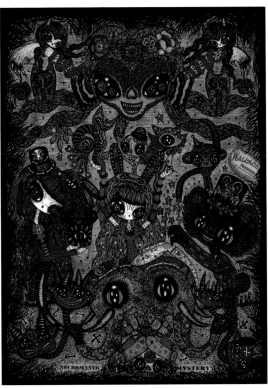

Mister Wallace Magician Company

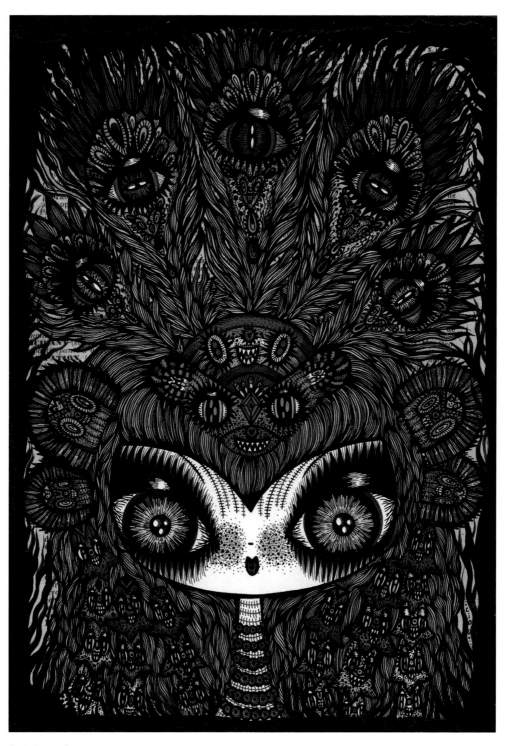

Rainbow Queen

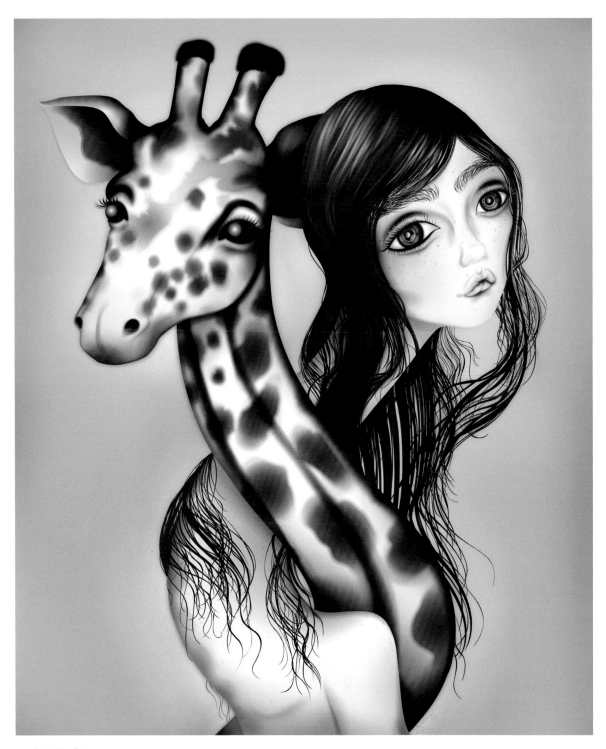

Giraffe Girl

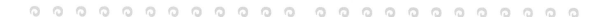

TANSY MYER

www.tansymyer.com

What is your inspiration?
I am inspired by music, fashion, nature, color and in my work, I like to explore the themes of female identity and empowerment.

What programs do you use to edit your works?
My drawings start as pencil drawings which I then color in Adobe Illustrator.

¿Cual es tu inspiración?
Me siento inspirada por la música, la moda, la naturaleza, el color. En mi trabajo, me gusta explorar los temas de la identidad y el poder femenino.

¿Que programas usas para editar tus trabajos?
Diseño mis dibujos a lápiz, luego doy color y textura utilizando el Adobe Illustrator.

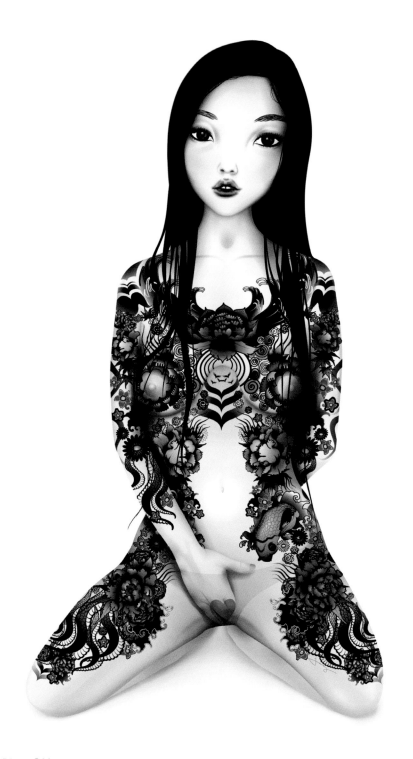

Blossom River Girl

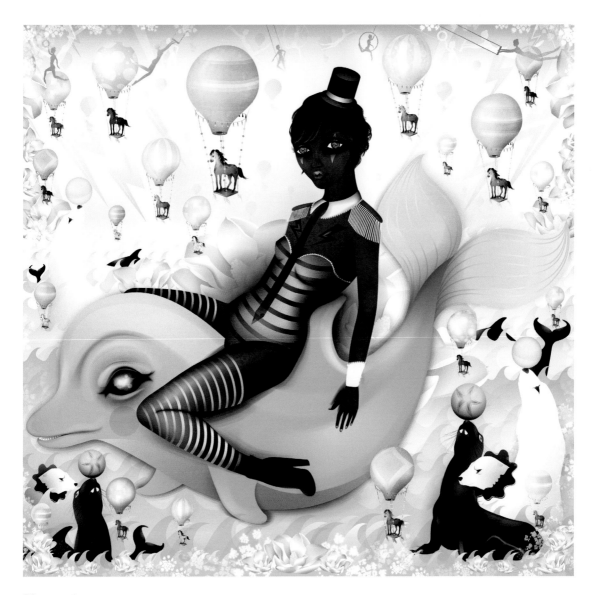

Ringmaster

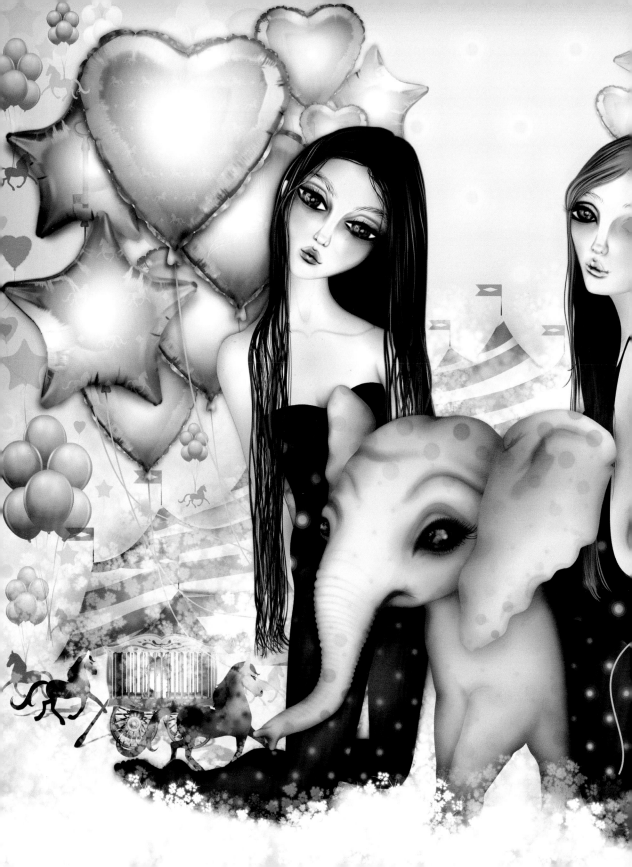

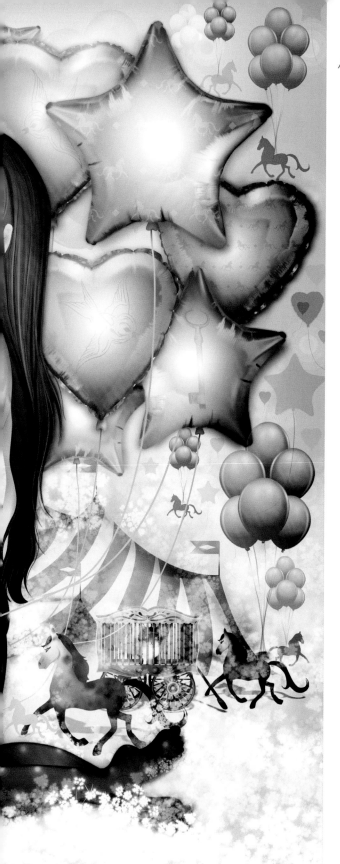

Acrobats

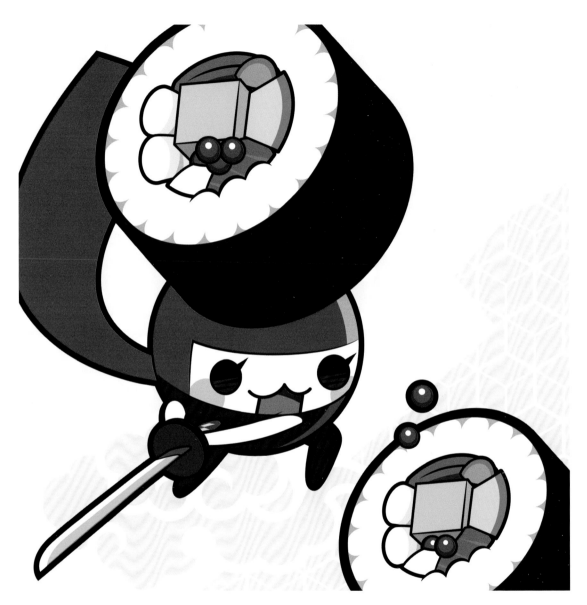

Chopper the Ehomaki

YUKIKO YOKOO

www.bukkoro.com

What is your inspiration?
The pop Japanese-style and Grotesque+Cute

¿Cual es tu inspiración?
El estilo pop japonés y el Grotesque+Cute.

What programs do you use to edit your works?
Primarily use Adobe Illustrator and Adobe Photoshop.

¿Que programas usas para editar tus trabajos?
Principalmente utilizo Adobe Illustrator y Adobe Photoshop.

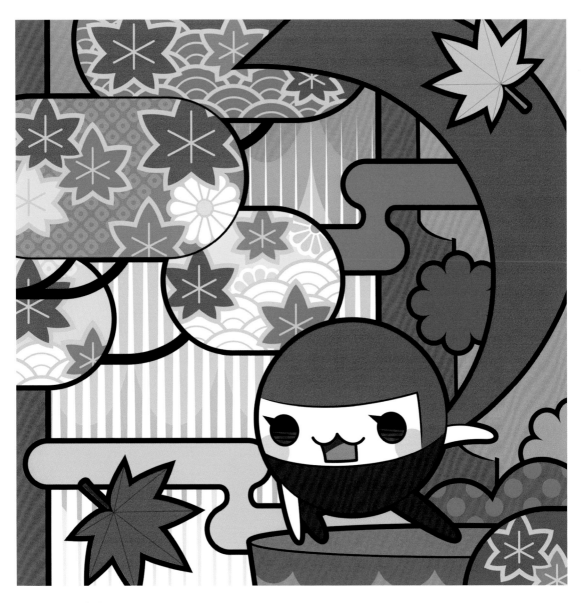

Deepening Autumn

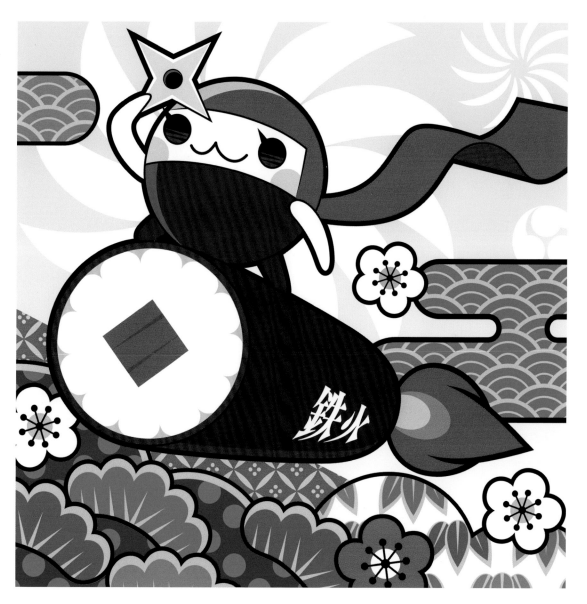

Go! Go! Gunkan

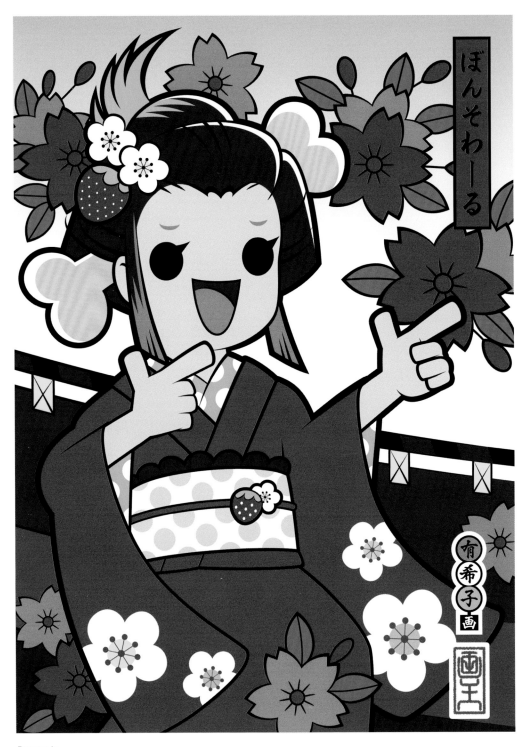

Bonsoir

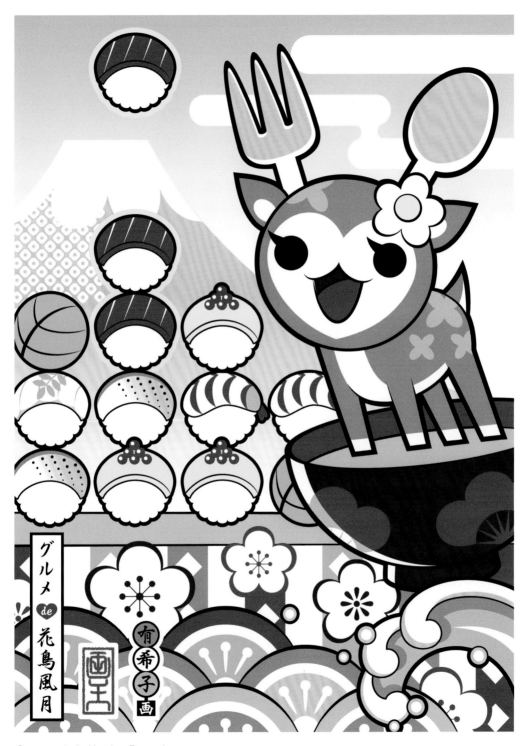

Gourmet de Kacho-Fugestu

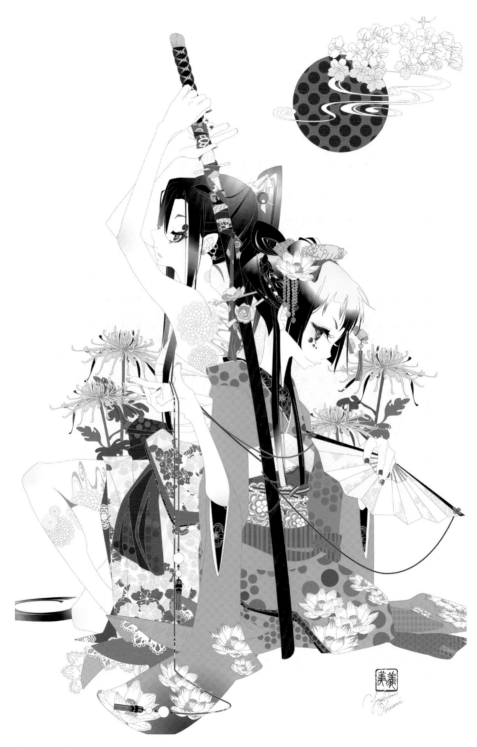

Samurai Geisha

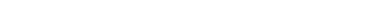

YOSHIMI OHTANI

www.funarium.com

What is your inspiration?
A walk at midnight, the beautiful molding of chocolate, that moment just before dawn, the dim sky and air. I have been inspired by these since childhood, and when I feel them coming in to my mind, my works sparkle.

What programs do you use to edit your works?
Adobe Illustrator CS3.

¿Cual es tu inspiración?
Un paseo a medianoche, el hermoso moldeado del chocolate, ese momento justo antes del amanecer, el cielo y el aire. Me han inspirado desde la infancia, y cuando pienso en ellos siento en mi mente esa chispa que fluye en mi trabajo.

¿Que programas usas para editar tus trabajos?
Utilizo Adobe Illustrator CS3.

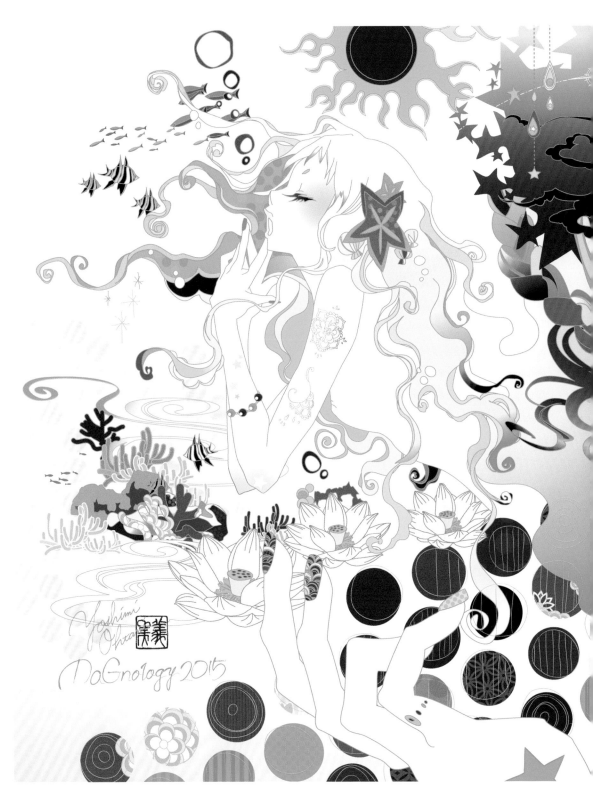

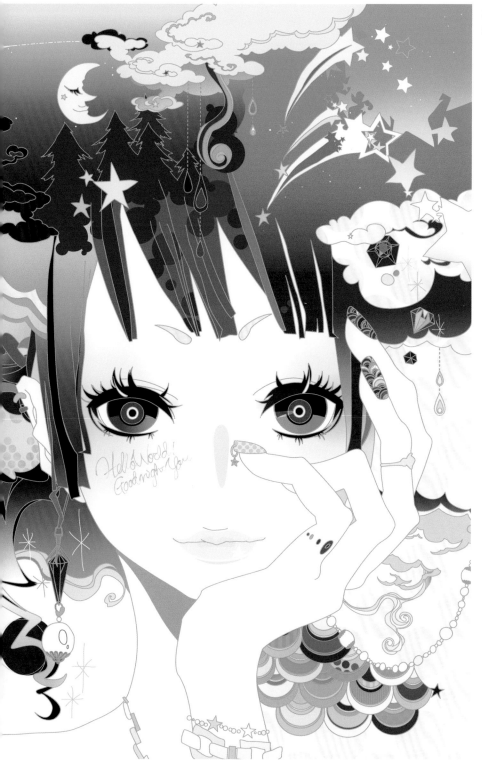

*Song of the sea and
Dawn of stardust*

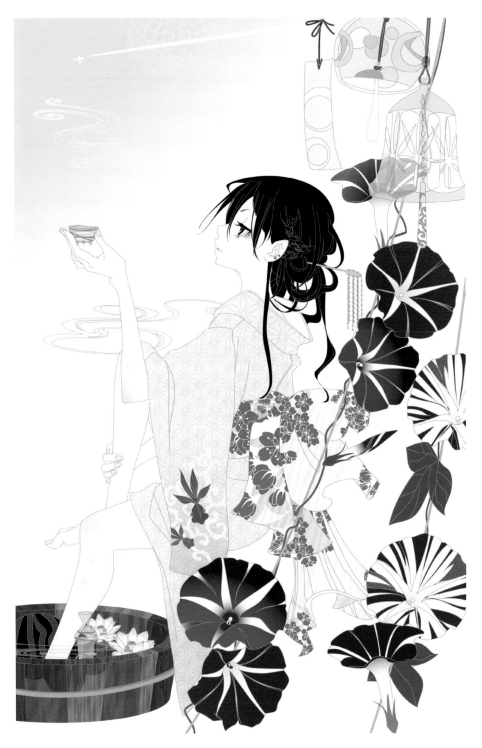

Wetted perimeter of cool

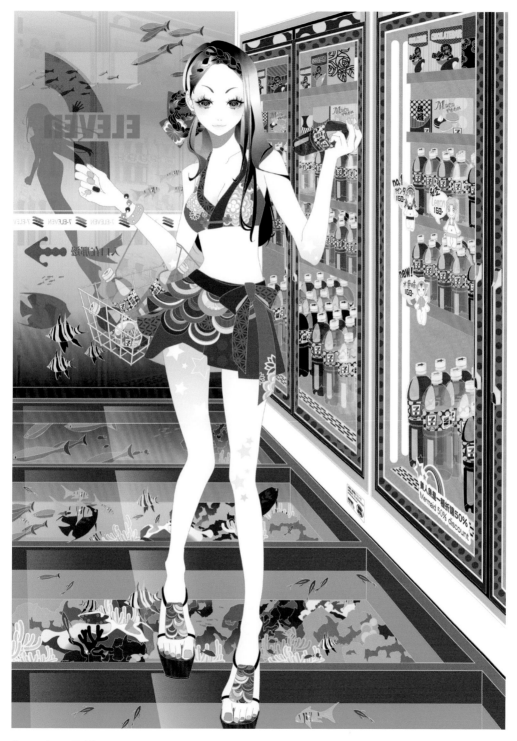

Aquarium 7-11

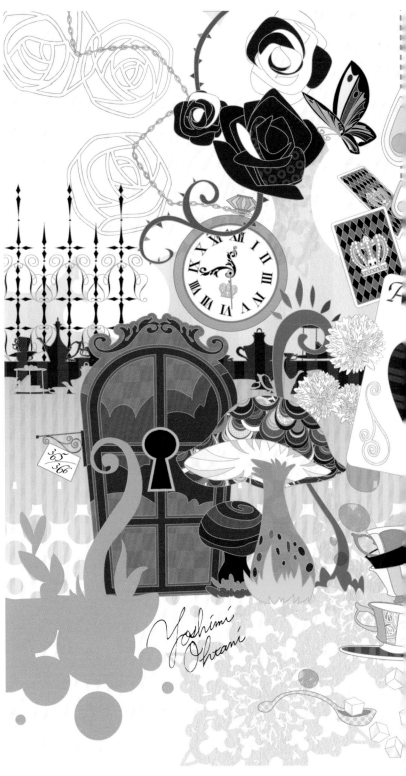

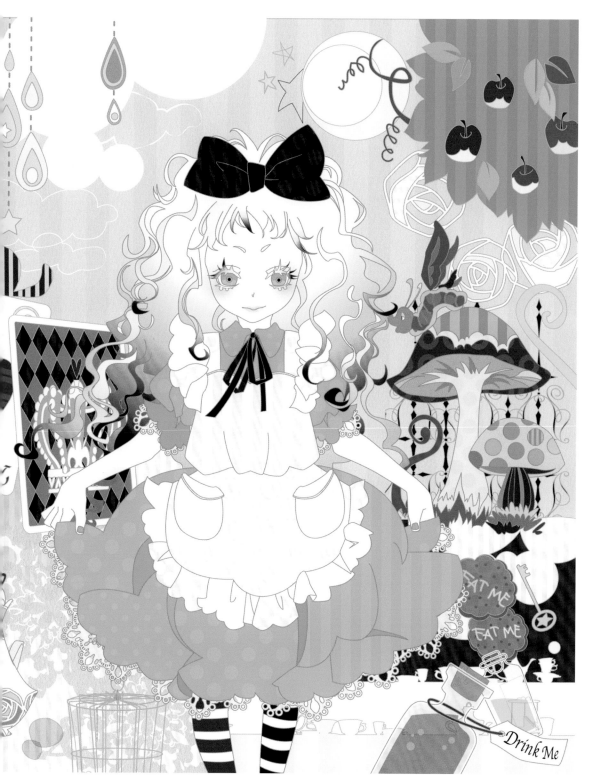

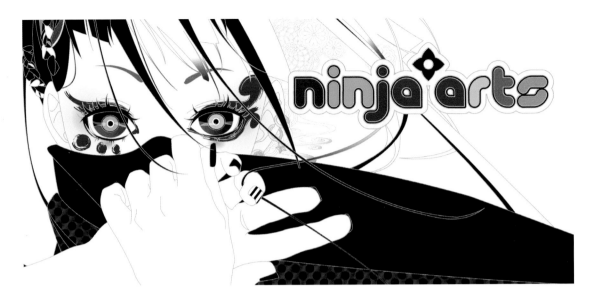

Ninja*arts

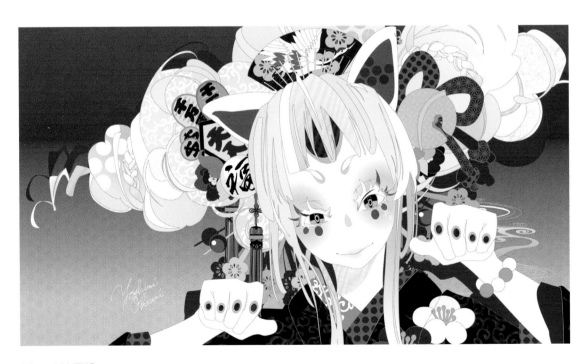

Maneki-NEKO

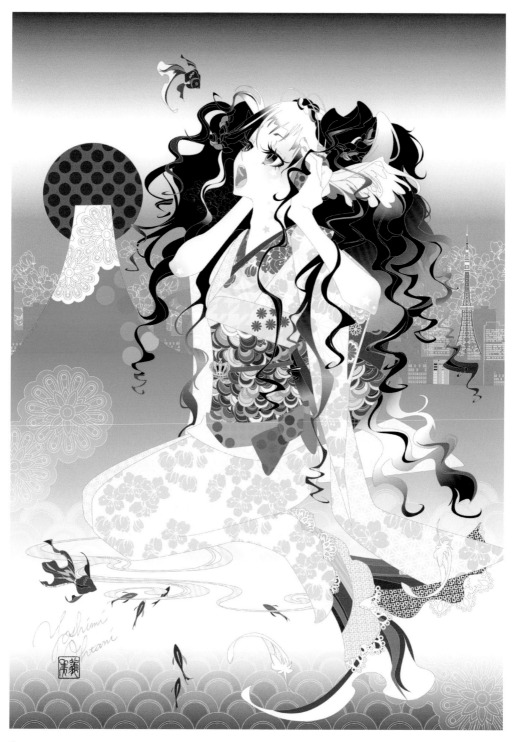

Song

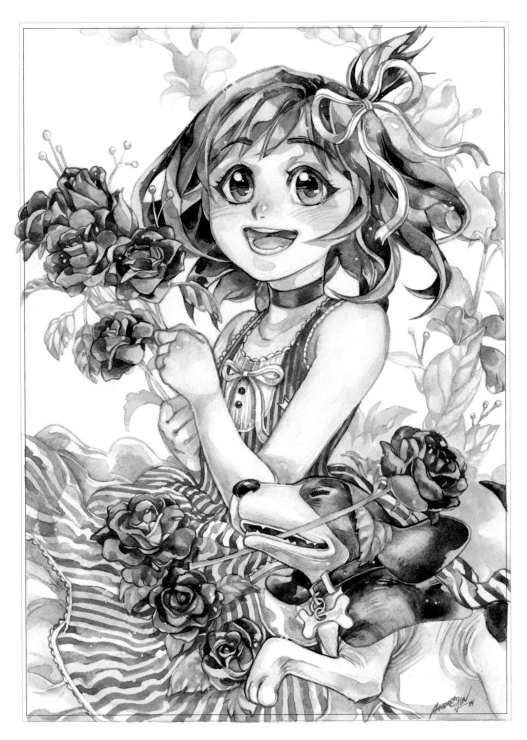

Who would you date

ANDREA JEN

https://es-es.facebook.com/andreajenart

What is your inspiration?
I get my inspiration from live experiences, from dreams and music.

What programs do you use to edit your works?
I use pencil to crate my works and use Adobe Photoshop to apply colours.

¿Cual es tu inspiración?
Me inspiro en las experiencias vividas, en los sueños y en la música.

¿Que programas usas para editar tus trabajos?
Creo mis trabajos a lápiz y uso Adobe Photoshop para cololorear.

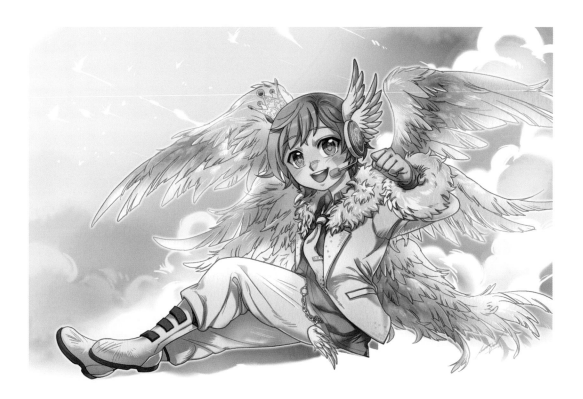

Jakey

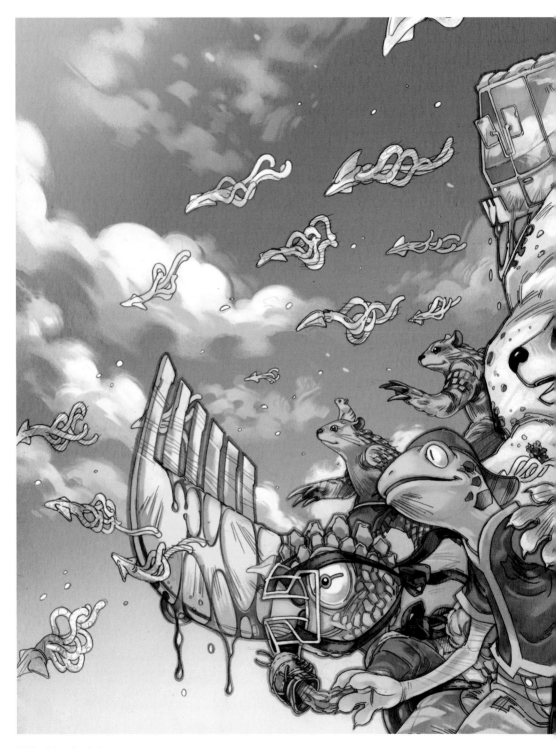

El Delirio de Ani

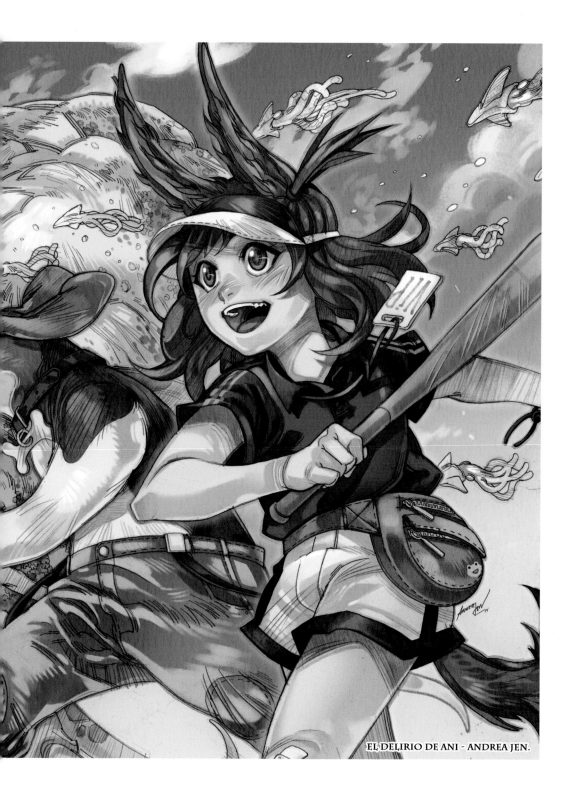

EL DELIRIO DE ANI - ANDREA JEN.

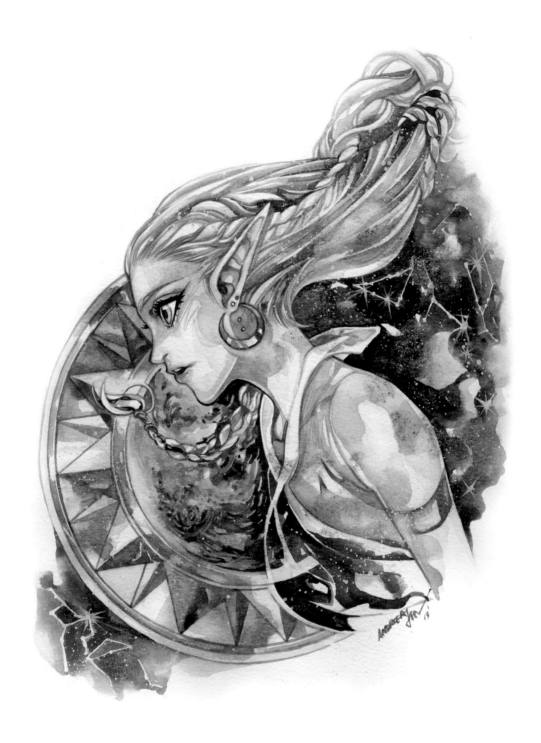

Astrology

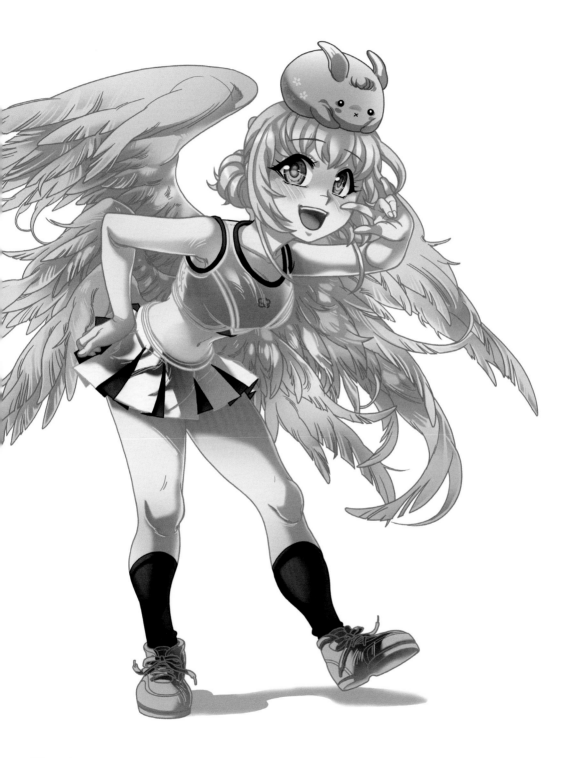

Channie

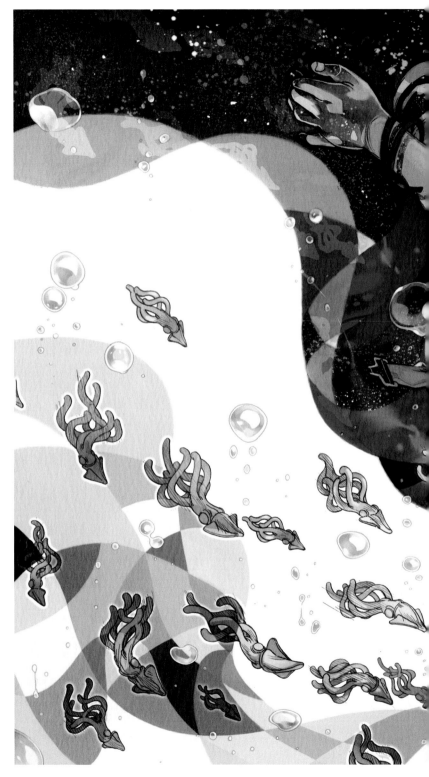

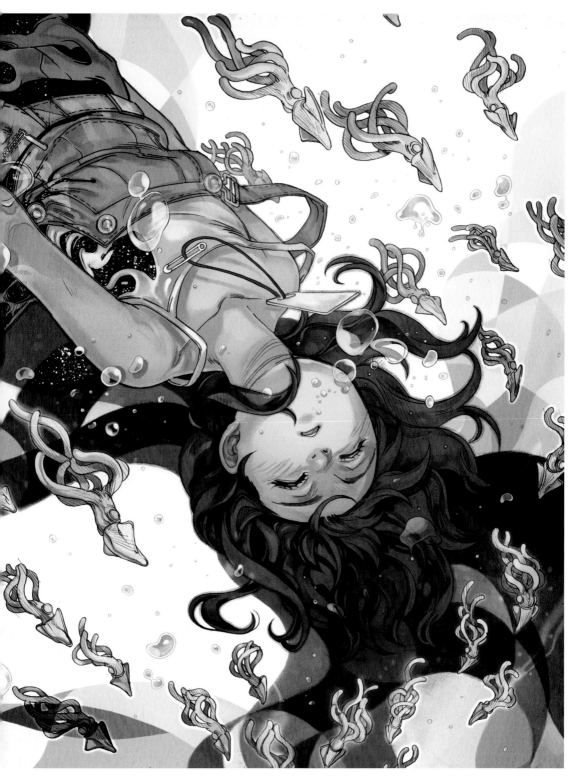

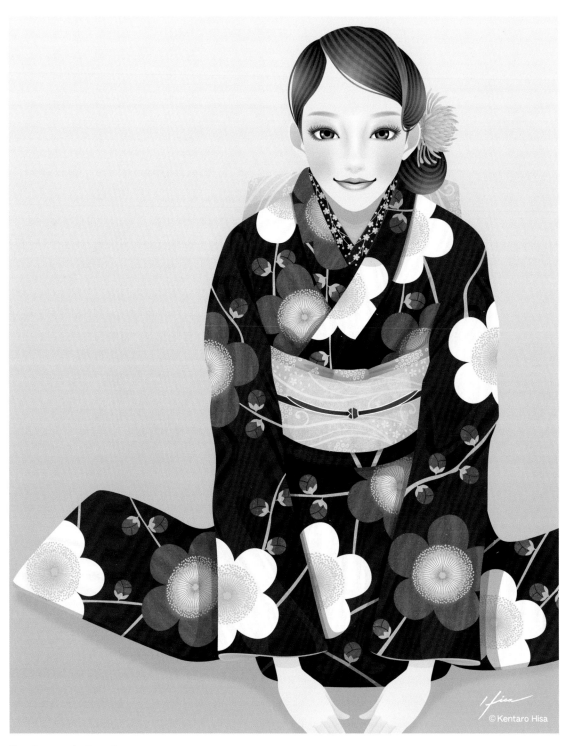

The Season's Greetings

KENTARO HISA

www.kentarohisa-illustration.com

What is your inspiration?
I find my inspiration in nature and life basically.

What programs do you use to edit your works?
I use Illustrator CS5.

¿Cual es tu inspiración?
Encuentro la inspiración en la naturaleza y la vida básicamente

¿Que programas usas para editar tus trabajos?
Utilizo Adobe Illustrator CS5.

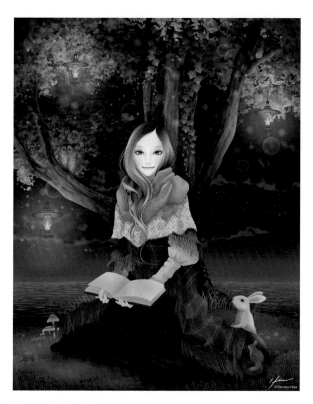

Beneath the tree

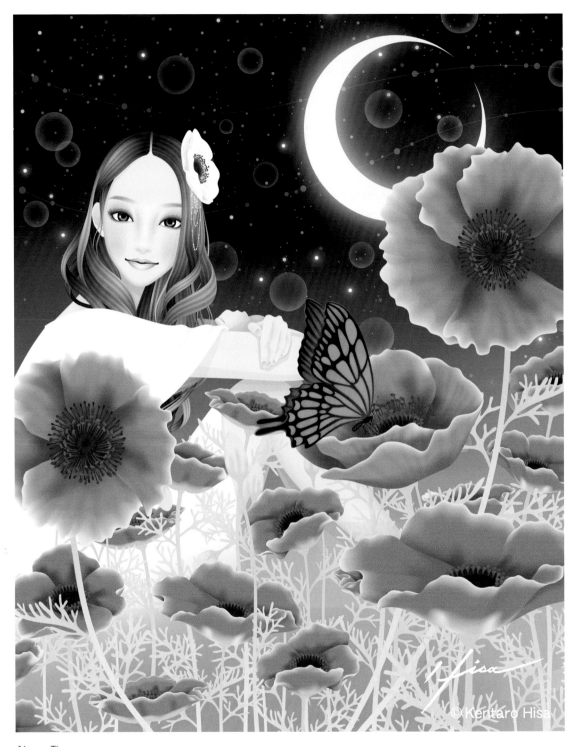

Alone Time

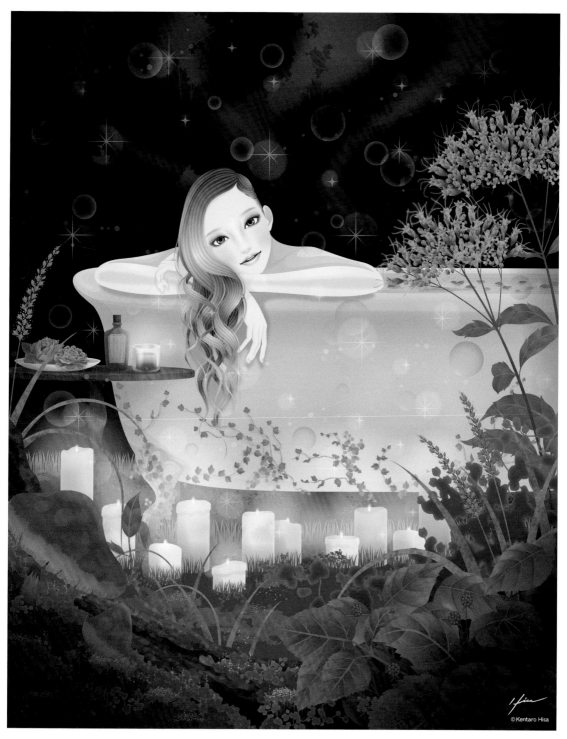

Extreme Happiness

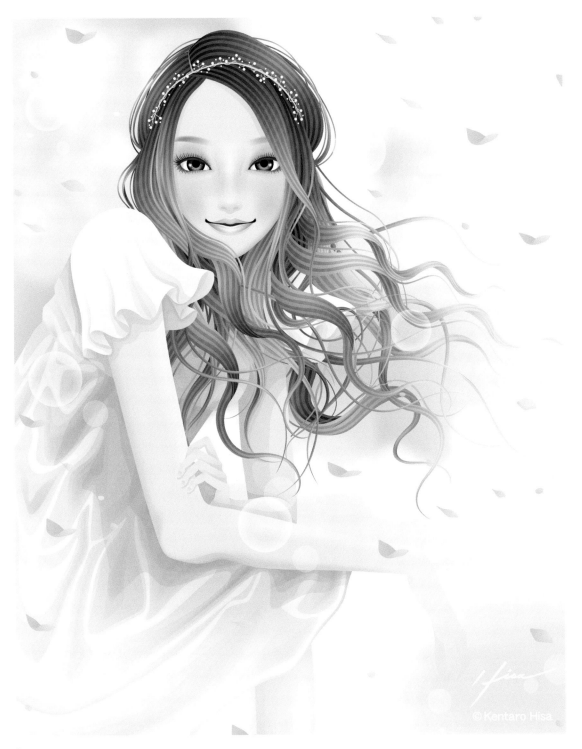

Breeze

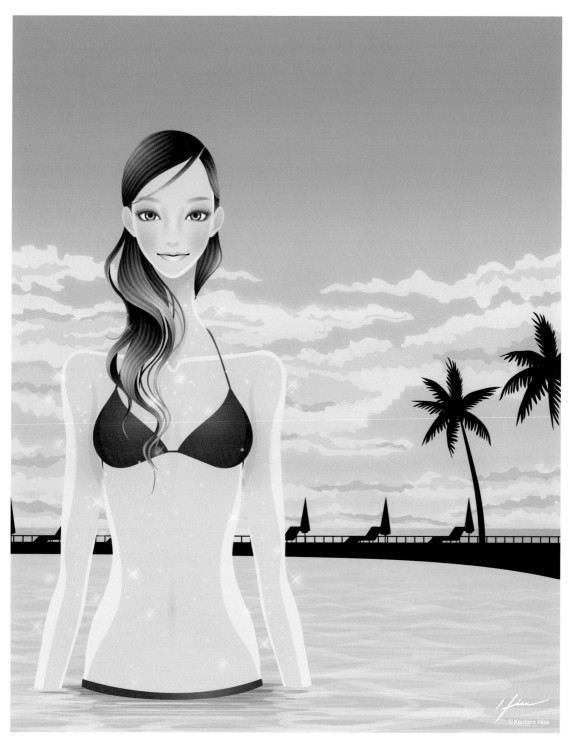

During twilight

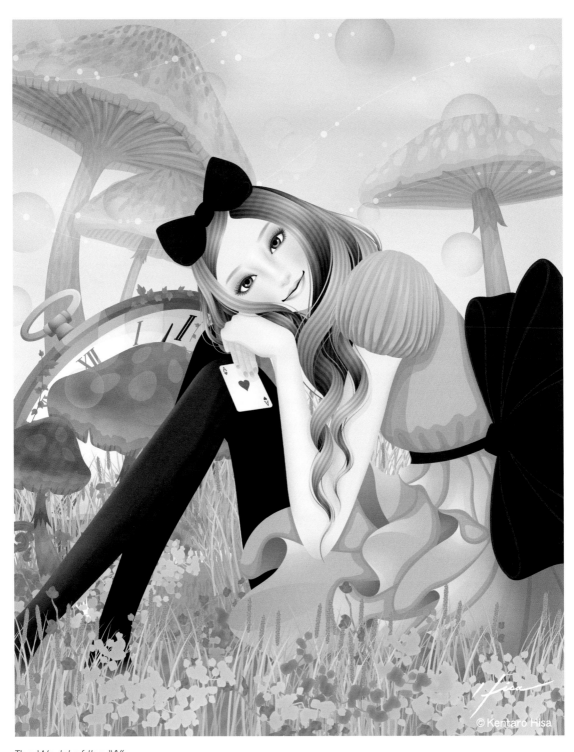

The World of the "A"

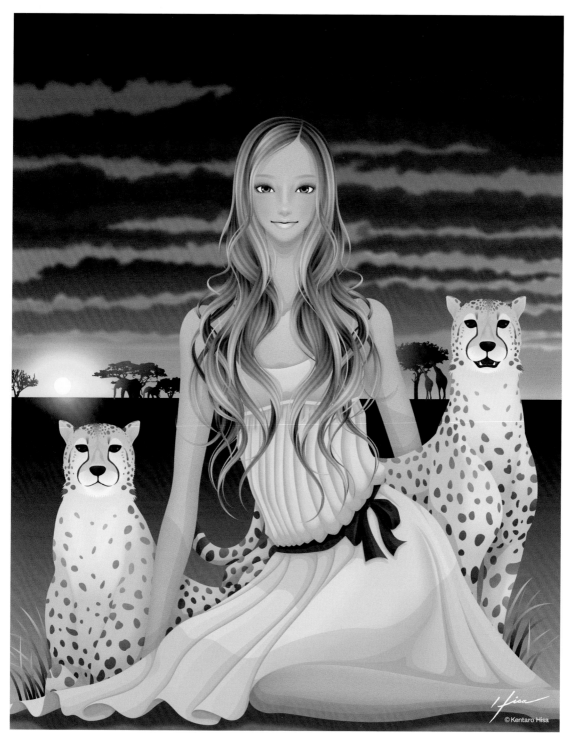

The Setting Sun

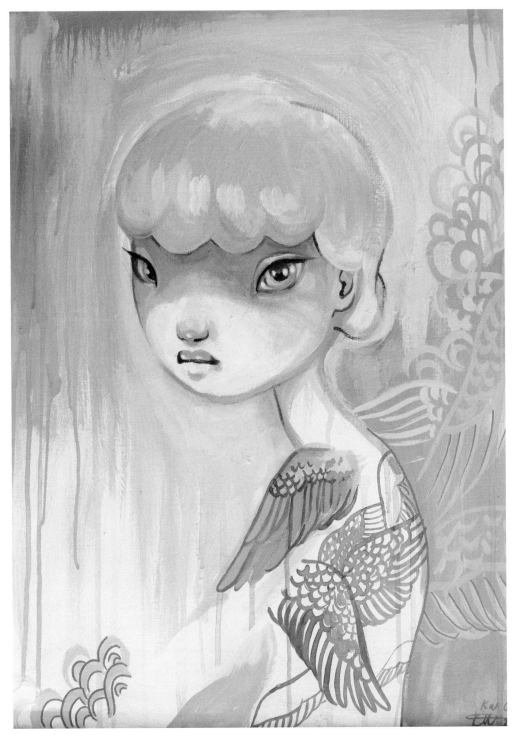

Winged

KAT CAMERON

www.katcameron.com

What is your inspiration?
The inspiration I find in Manga and Anime stems from watching cartoons as a teenager and then being drawn into the curious worlds of anime feature films. I loved the luminous eyes, the narratives, the delightful use of color, and most importantly the amazing imagination that went into all the artwork. I spent two years living in Japan and this did much to cement my love of the genre. Now my work features an amalgamation of influences - from growing up in Africa, traveling in Asia to living in Europe. Each character has a story and a life beyond the canvas.

What programs do you use to edit your works?
I mostly use Adobe photoshop in my artworks, however it's usually a mixture of gauche, acrylic, watercolor and pencil which is then scanned and reworked in Photoshop, adding layers and texture.

¿Cual es tu inspiración?
La inspiración que encuentro en el Manga y el Anime, deriva de los dibujos animados, que veía cuando era una adolescente y me arrastraron a los curiosos mundos de los largometrajes anime. Me encantan los ojos luminosos, las narraciones, el uso delicioso de color, y lo más importante, la increíble imaginación que desprende toda la obra. Me pasé dos años viviendo en Japón y esto hizo mucho para cimentar mi amor por el género. Ahora mi trabajo cuenta con una amalgama de influencias, de crecer en África, viajar por Asia y vivir en Europa. Cada personaje tiene una historia y una vida más allá del lienzo.

¿Que programas usas para editar tus trabajos?
Mayormente utilizo Adobe Photoshop en mis obras, sin embargo, por lo general siempre las inicio con una mezcla de acrílico, acuarela y lápiz que luego escaneo y acabo trabajando en Adobe Photoshop, añadiendo capas y textura.

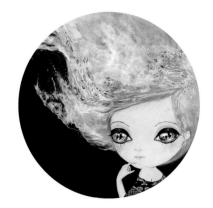

Wonder Fire by Miss Yucki

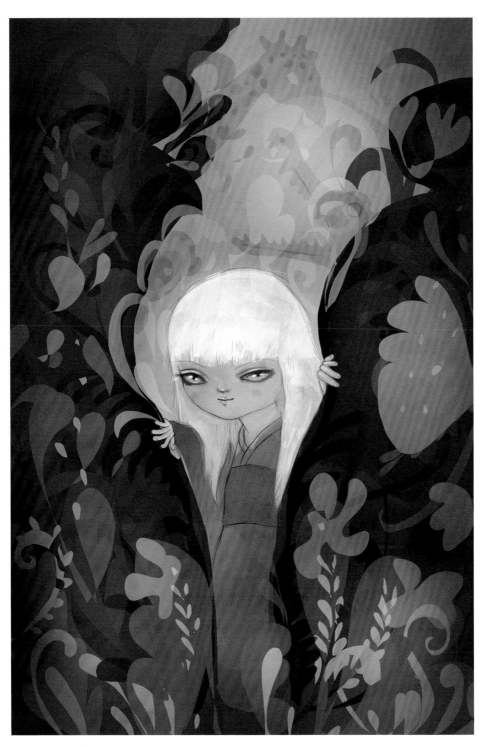

Little Jungle Girl

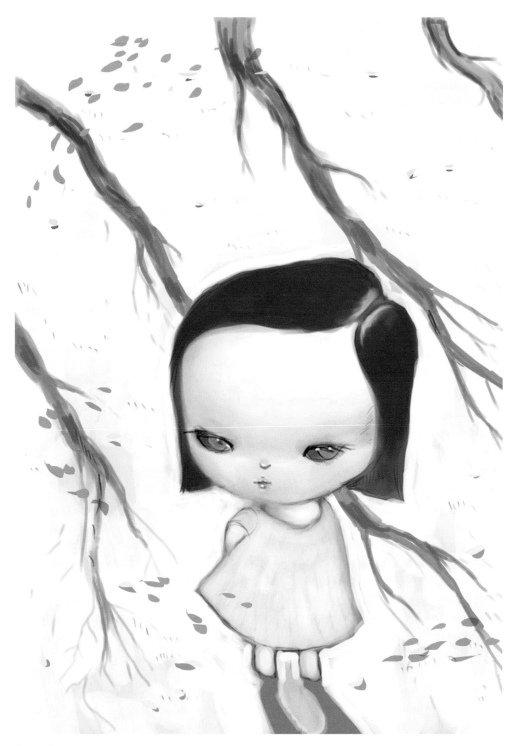

Snow Shadows

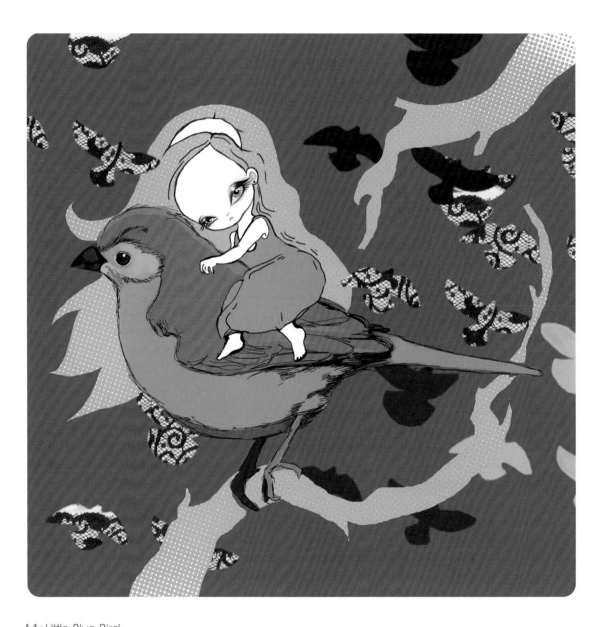

My Little Blue Bird

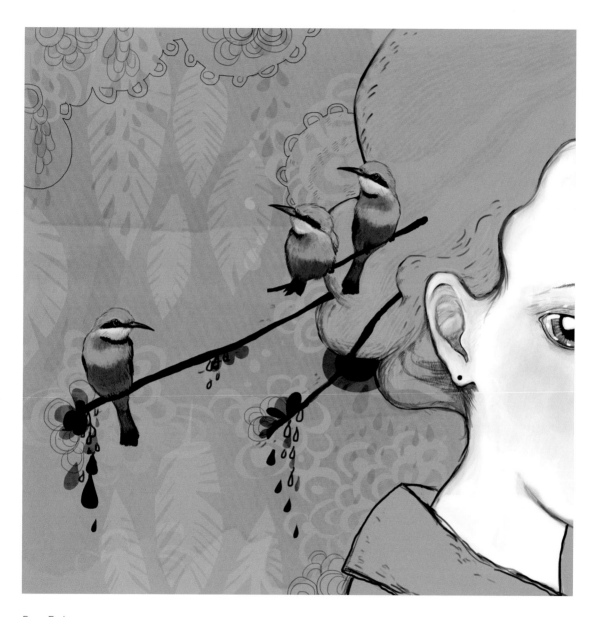

Bee Eater

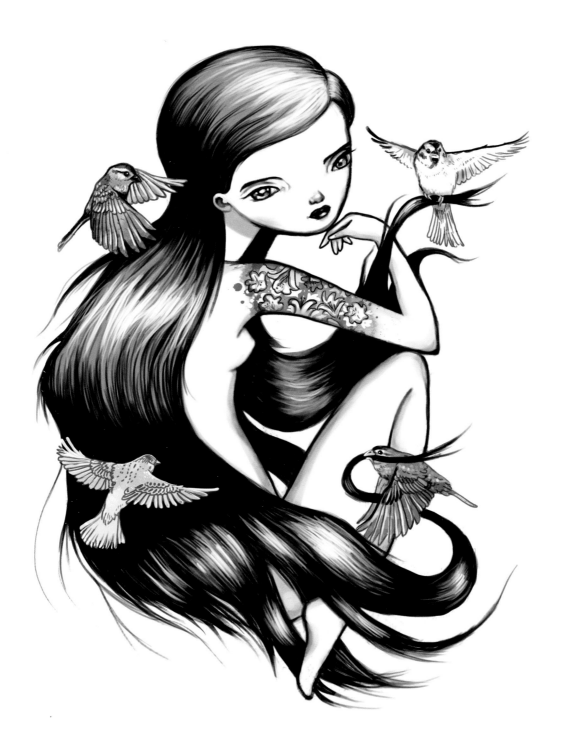

Envelop

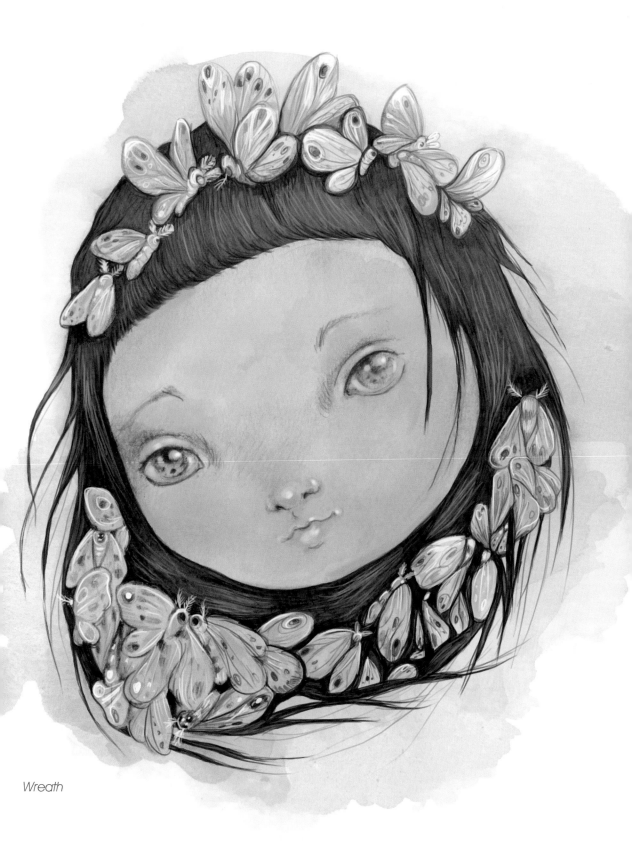

Wreath

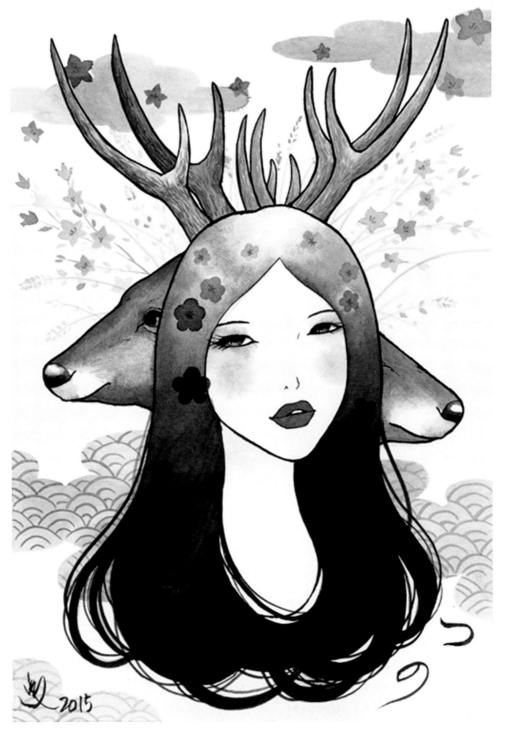

Horn

YUMIKO KAYUKAWA

www.sweetyumiko.com

What is your inspiration?
Wild life, music, movies, fashion, politics and anything happening in my life.

What programs do you use to edit your works?
They are all hand work with acrylic and paint brush. I have no programs to work with it.

¿Cual es tu inspiración?
La vida salvaje, la música, las películas, la moda, la política y todo lo que sucede en mi vida.

¿Que programas usas para editar tus trabajos?
Trabajo a mano, pinceles y pintura acrílica. No utilizo programas para editar mis trabajos.

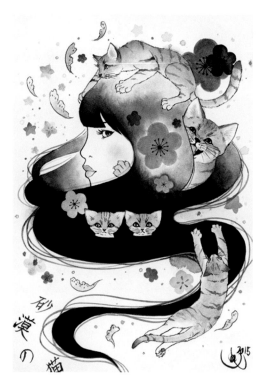

Sand Cat

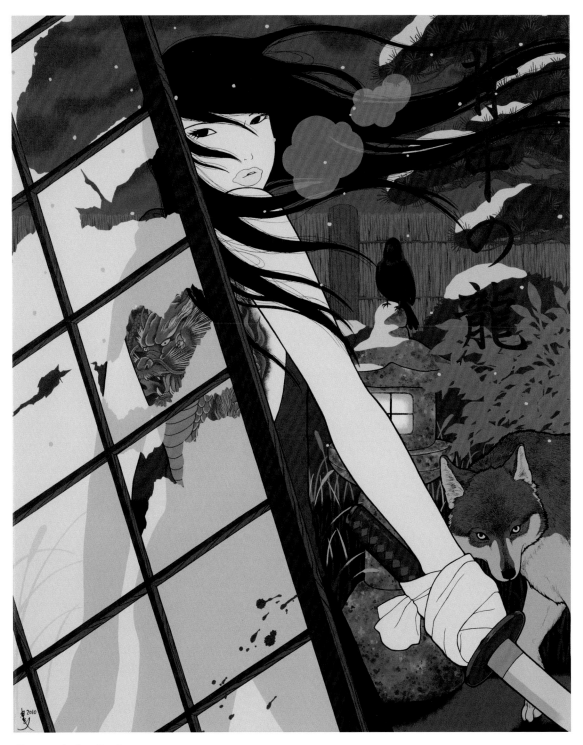

Dragon in the Back

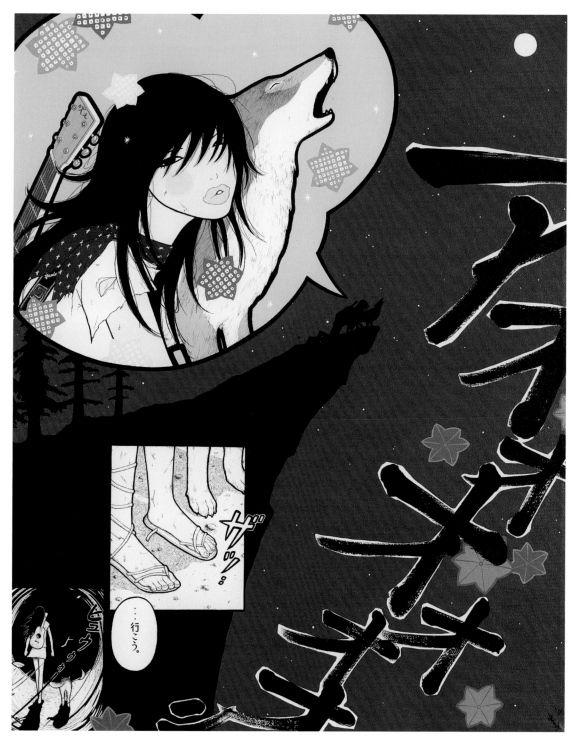

Howwwwwwl

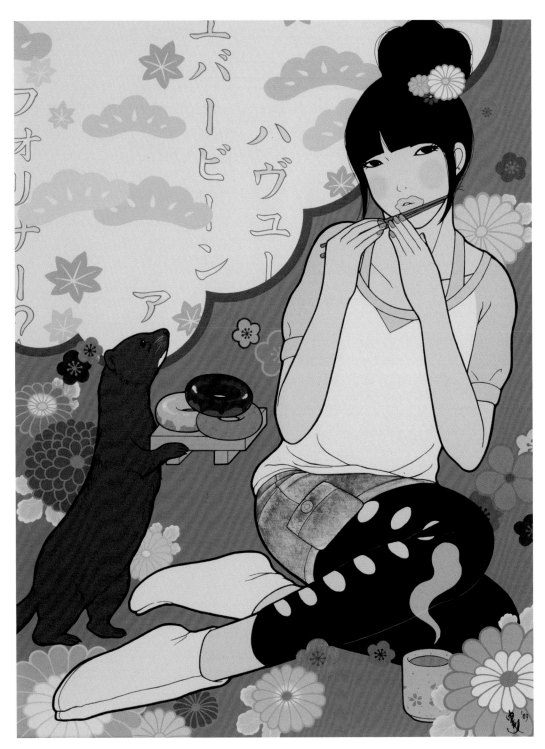

Have you ever been a foreigner

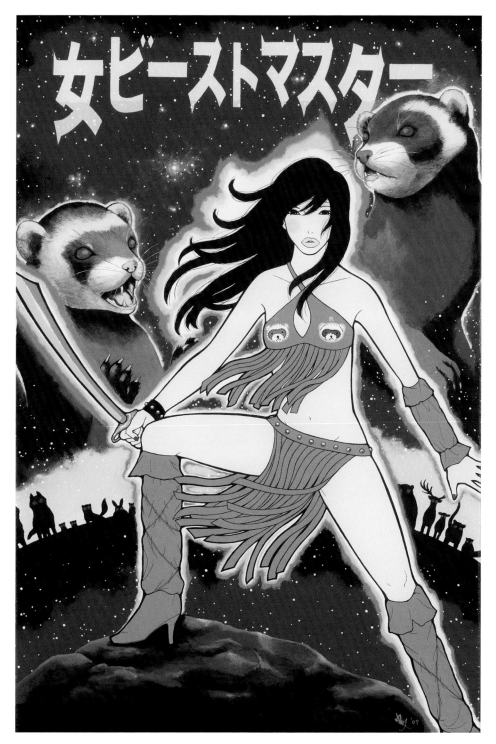

Lady Beast Master

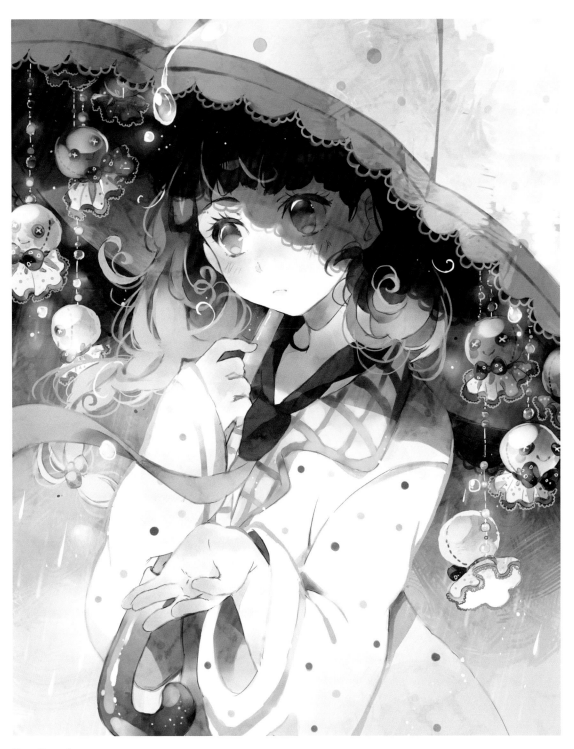

Teru Teru Bozu

HETIRU

www.hetiru.deviantart.com

What is your inspiration?
I receive inspiration from everywhere - situations or happenings in the real life, from music, from artworks drawn by different artists... everything that surrounds me.

What programs do you use to edit your works?
Usually I use Paint Tool SAI and Adobe Photoshop CS6.

¿Cual es tu inspiración?
Recibo la inspiración por todas partes - situaciones o acontecimientos en mi vida, desde la música, las obras de arte elaboradas por diferentes artistas... todo lo que me rodea.

¿Que programas usas para editar tus trabajos?
Normalmente uso Paint Tool SAI y Adobe Photoshop CS6.

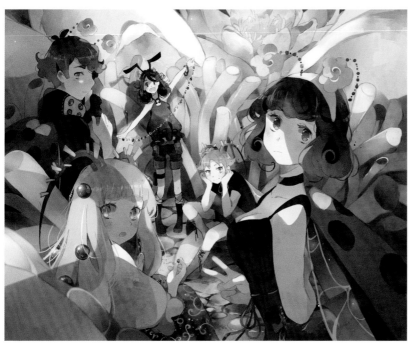

The Hottest day of August

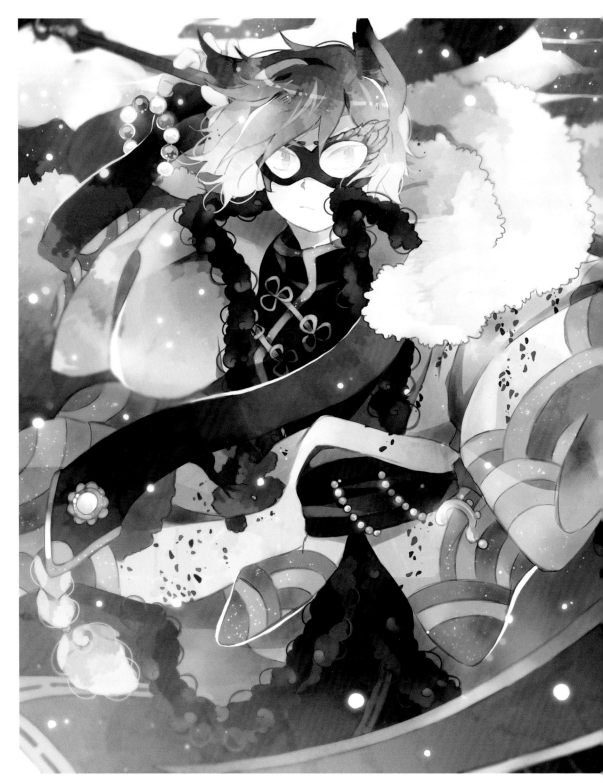

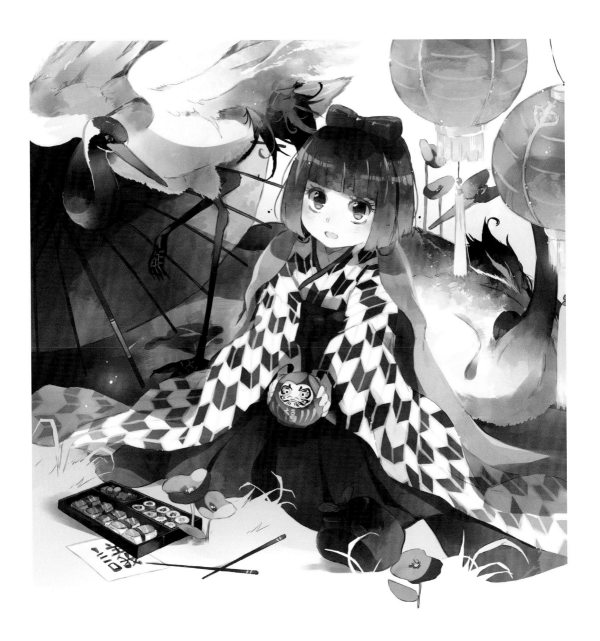

Red Crowned Cranes

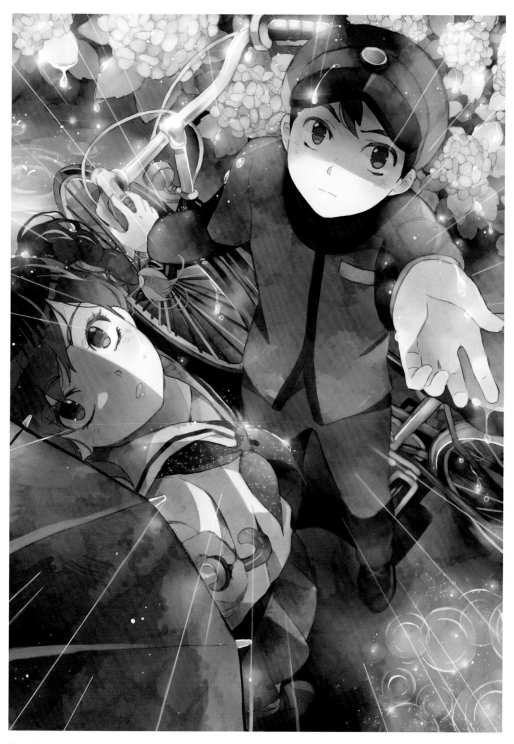

The Rain of Happiness and Sorrow

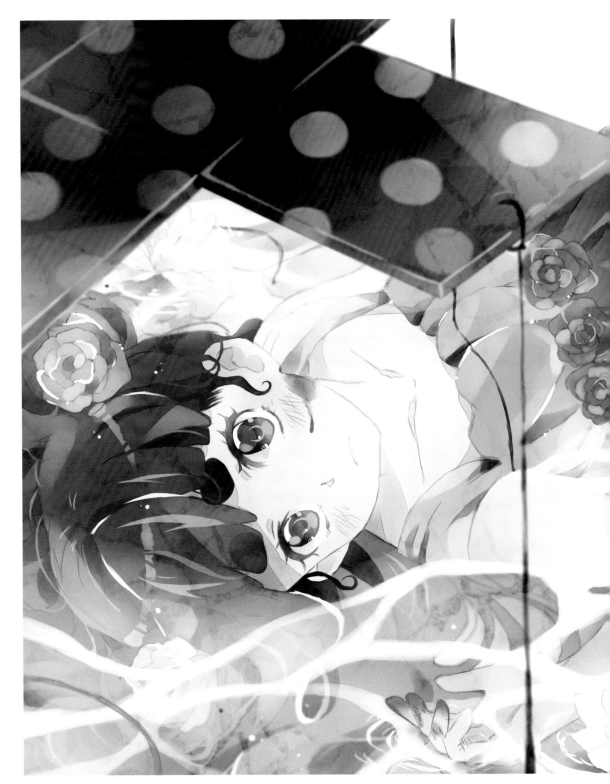

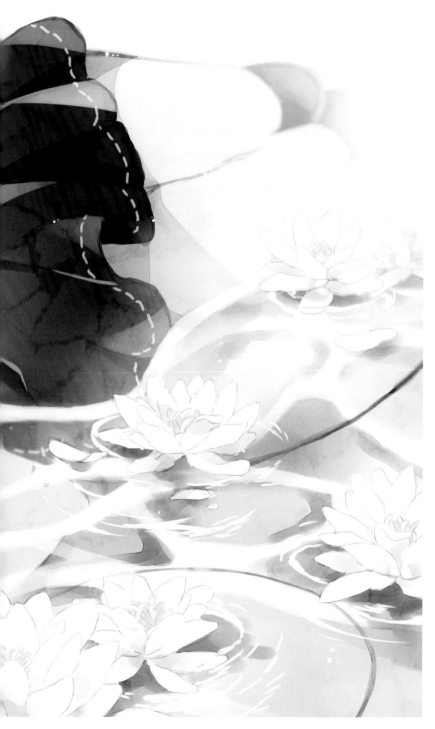

*Please, give me life
once again.*

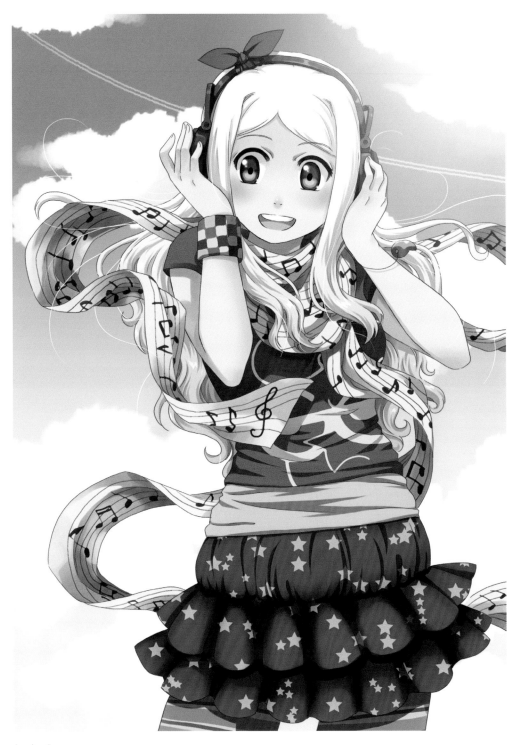

La La La

MEAGO

www.meagolicious.com

What is your inspiration?
My inspirations are bright, colorful photos, places, or fashion designs. Big influence is also food, and beautiful images from cookbooks or food blogs. I love modern taste, and shapes... Looking at beautiful exposed dish, interiors, paintings, or magazine photo sessions motivates me a lot.

What programs do you use to edit your works?
For my pictures I am using Paint tool sai and Adobe Photoshop.

¿Cual es tu inspiración?
Me suelo inspirar en las fotografías que hago, en la luminosidad y los colores, lugares y diseños de moda. También suelo buscar la inspiración en la comida, en los libros de recetas y en diferentes blogs de alimentación. Me gustan las formas modernas, las exposiciones, la pintura y las sesiones de fotos que encuentro en diferentes revistas de moda.

¿Que programas usas para editar tus trabajos?
Para mis trabajos utilizo Paint Tool SAI y Adobe Photoshop.

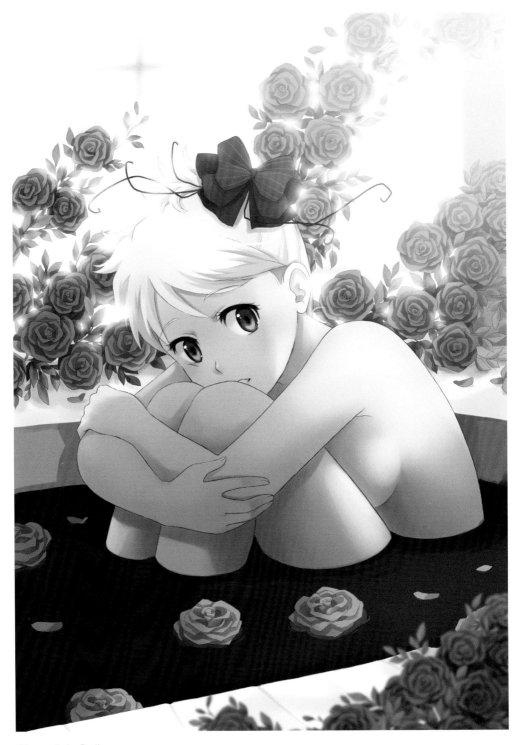

Chocolate Bath

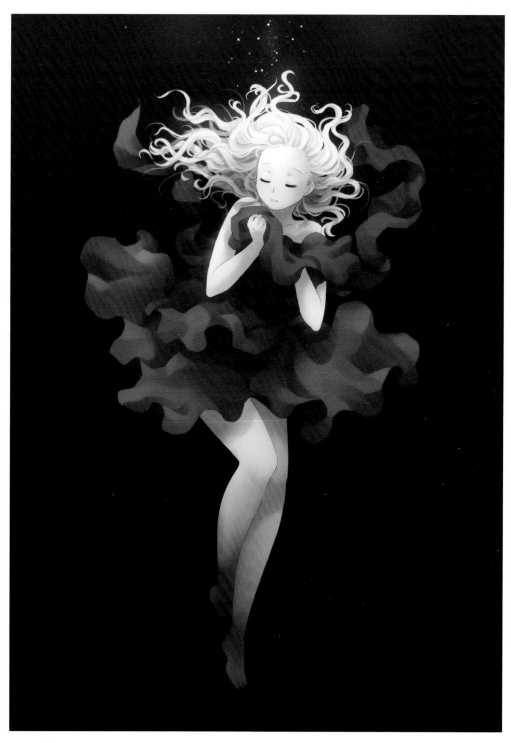

Under Water

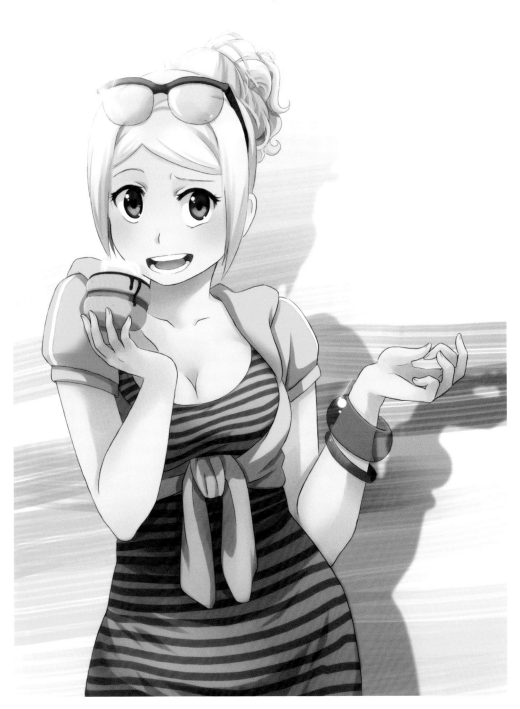

I Like Cakes

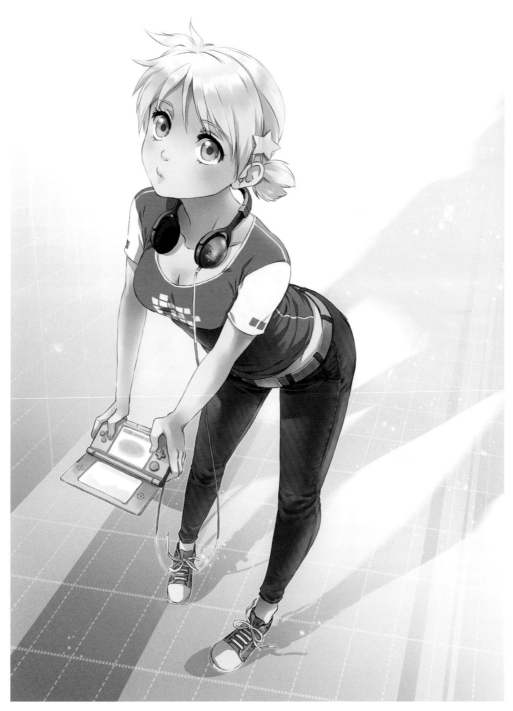

Gamer Girl Emily

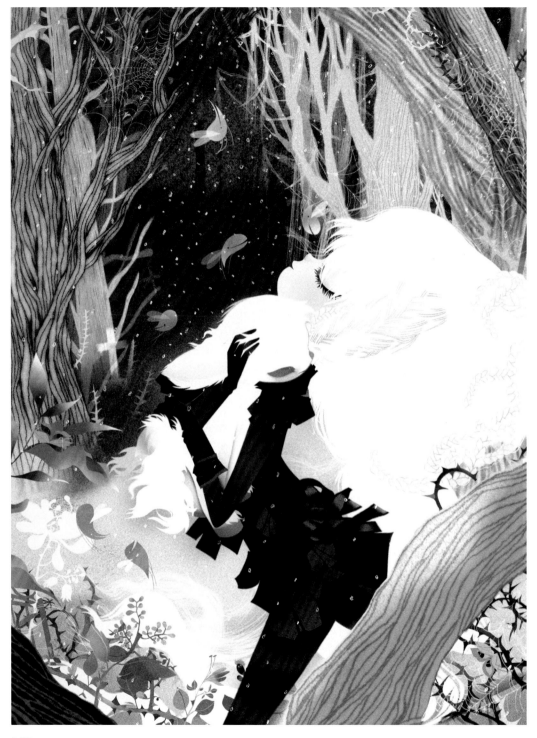

Milky

LILIDOLL

www.lilidoll-minidoll.blogspot.com

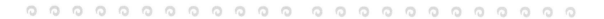

What is your inspiration?
My inspiration comes from ancient objects, books of my childhood, movies and games. Apart from vintage figures and stuffed toys, such as deer and rabbits.
I love the design of the '50s, gadgets that have had a long life before coming home, they are unique and have soul, sometimes they are a little broken, but I love her extravagant appearance. Dolls and fashion are also a strong source of inspiration for me.

What programs do you use to edit your works?
I use Chinese ink, crayons, markers, paint, watercolor and my computer. I love making my drawings by using only a pencil, after that I convert my image into a digital work, and then I create more details and apply the lights.

¿Cual es tu inspiración?
Mi inspiración viene de objetos antiguos, libros de mi niñez, películas y juegos. Aparte de figuras añejas y muñecos de peluche, como ciervos o conejos. Me gusta el diseño de los años 50, los artefactos que han tenido una vida larga antes de venir a casa, ellos son únicos y tienen el alma, a veces están un poco rotos, pero me gusta su aspecto extravagante. Las muñecas son también una fuente fuerte de inspiración para mí.

¿Que programas usas para editar tus trabajos?
Uso la tinta china, barras de lápiz, marcadores, pintura, acuarela y mi ordenador. Me gusta hacer mis dibujos usando sólo un lápiz, después lo convierto en una imagen digital, donde le aplico luces y añado los detalles.

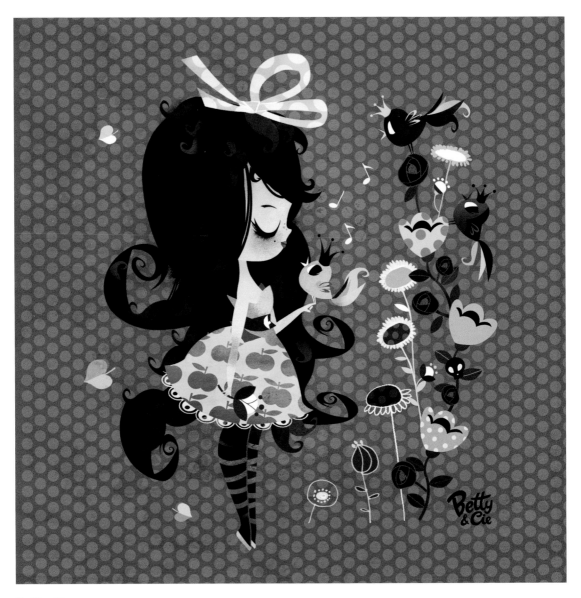

Petites Pensees

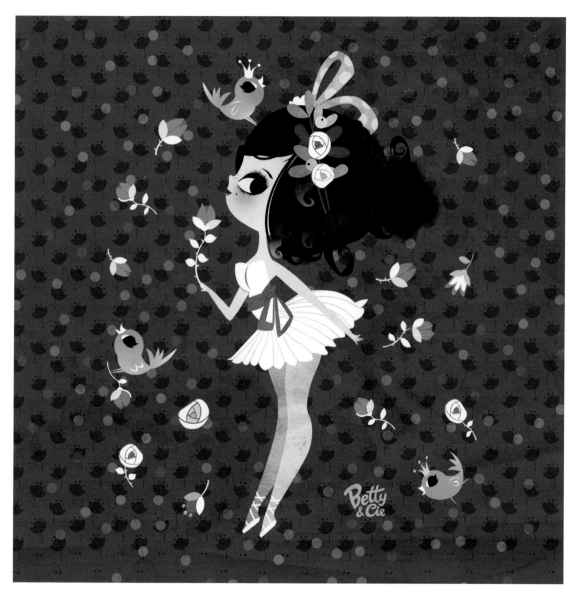

Premiere Danseuse

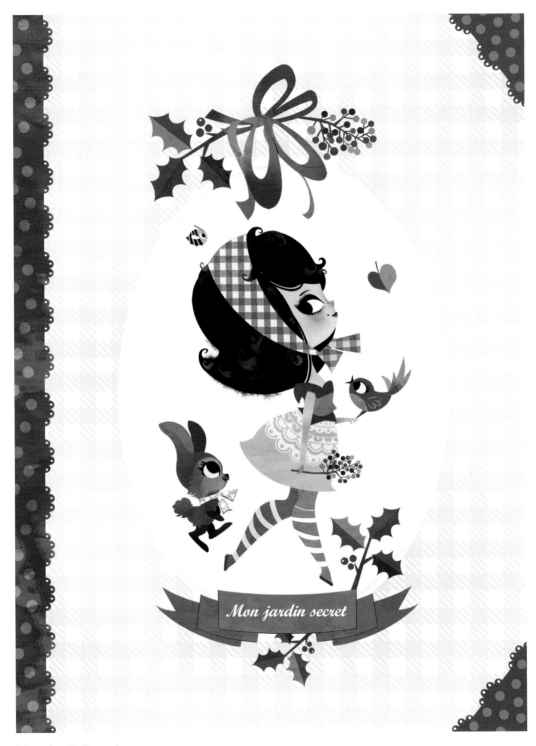

Mon Jardin Secret

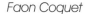
Faon Coquet

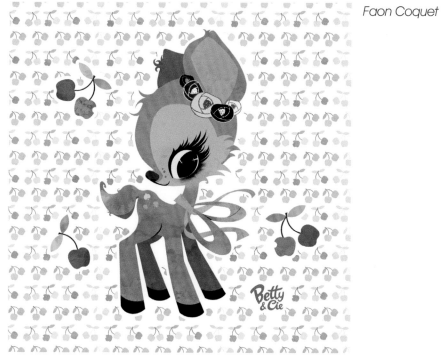

Jolis Confettis

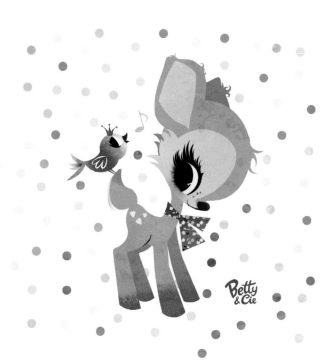

Arc-En-Ciel

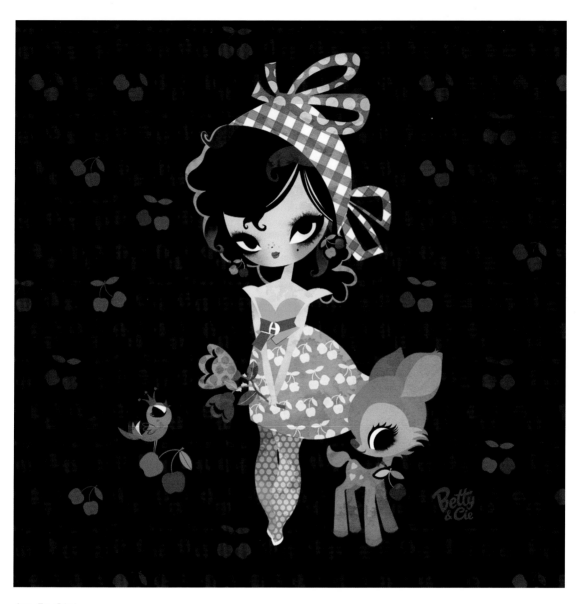

Arc-En-Ciel

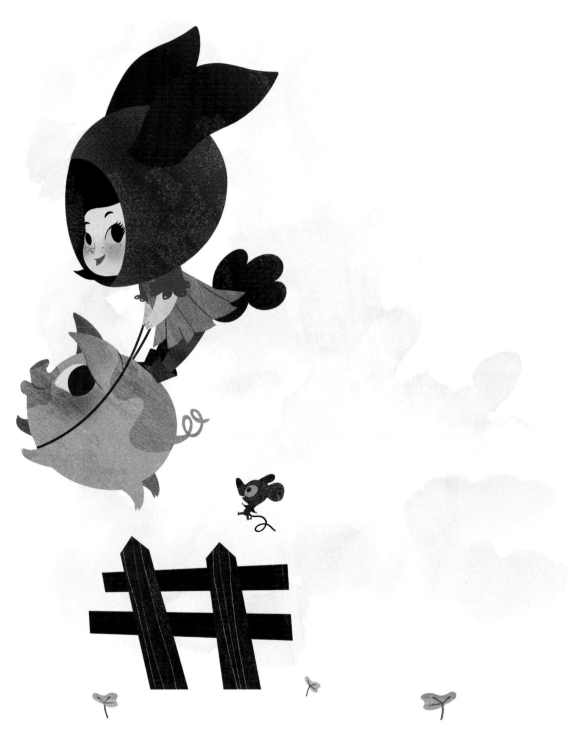

Farmers

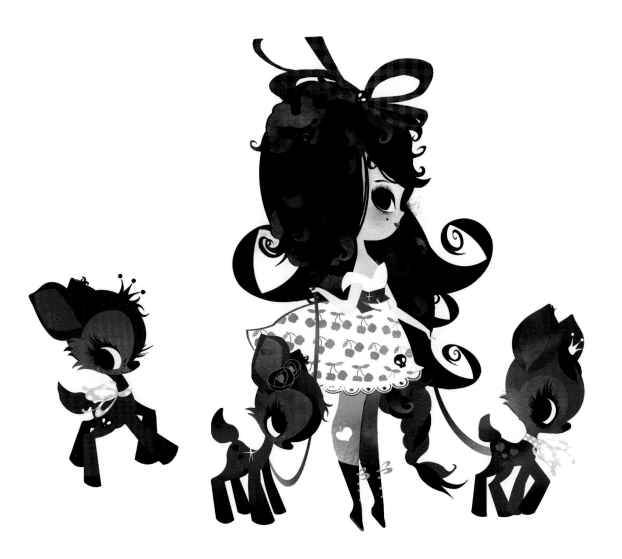

Promenade

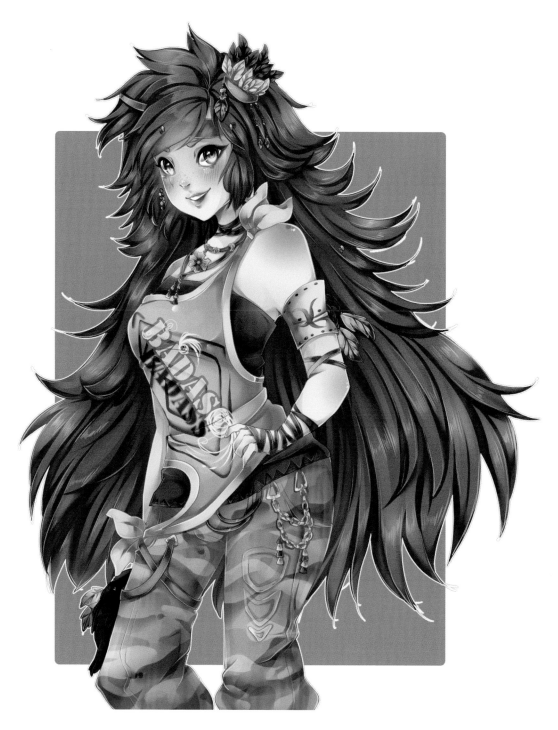

Girl like Fire

LADOLLBLANCHE

www.ladollblanche.deviantart.com

What is your inspiration?
Music is my biggest inspiration, I always need new music fitting the mood.
The artworks by some other artists are also inspiring. I love watching different anime and cartoon styles, also video games, it makes me improve my drawing style, and add something new. And of course nature, it always makes me want to improve at backgrounds, drawing beautiful landscapes.

What programs do you use to edit your works?
I use Paint Tool SAI and Adobe Photoshop.

¿Cual es tu inspiración?
La música es mi inspiración más fuerte, necesito la música que encaje con mi humor en ese momento para poder trabajar. Los materiales gráficos de algunos artistas son también inspiración para mi. Los diferentes estilos de anime y los videojuegos son también fuente de inspiración. Y desde luego la naturaleza, esto siempre me ayuda para crear los fondos de mis trabajos, creando hermosos paisajes.

¿Que programas usas para editar tus trabajos?
Me gusta utilizar Paint Tool SAI y Adobe Photoshop.

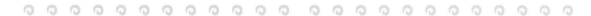

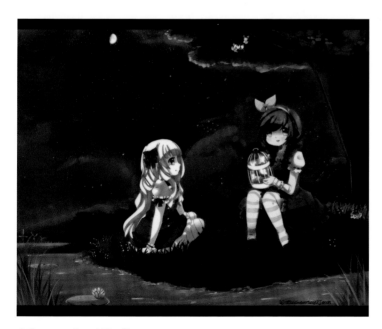

A Serenade of Fireflies

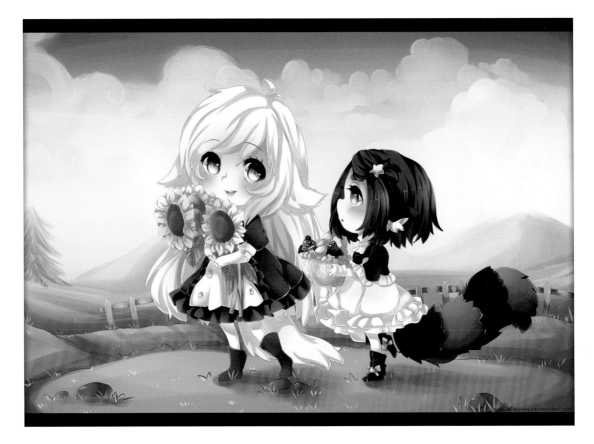

Summer's eve

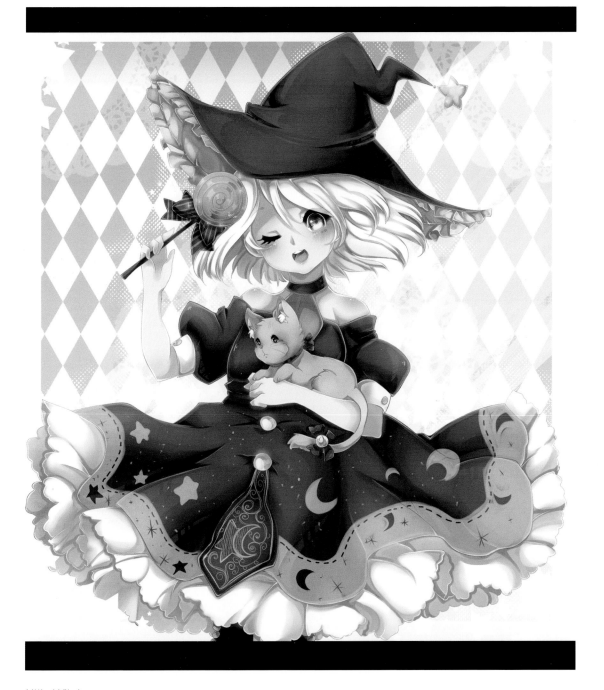

Little Witch

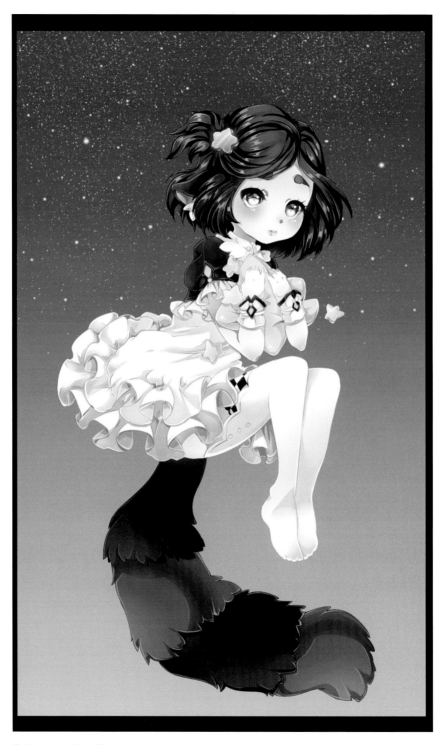

Esther and the Stars

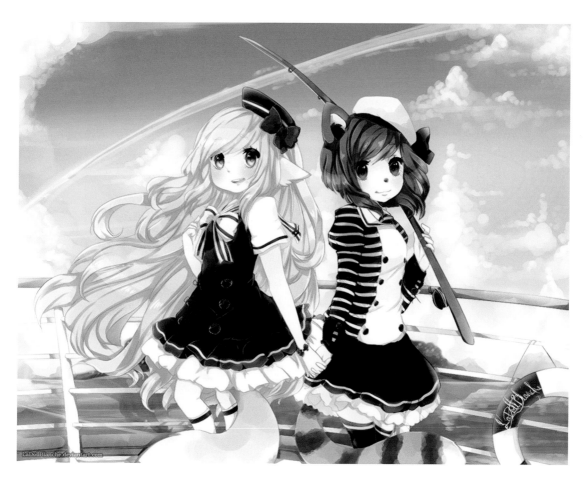

Sailors

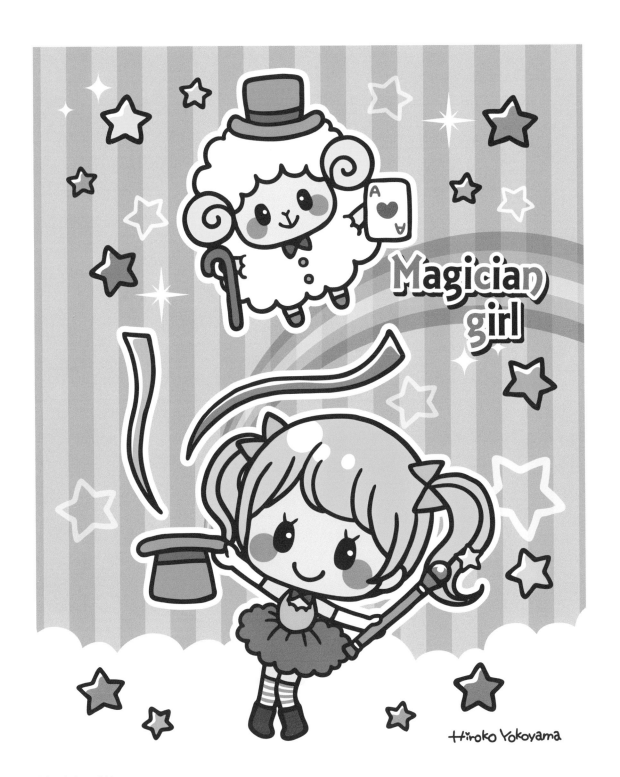

Magician girl

Hiroko Yokoyama

Magician Girl

HIROKO YOKOYAMA

www.yokoyama-hiroko.com

What is your inspiration?
All the cute things in the world is my inspiration.
Fantasy, sweets, cute girls and animals will inspire my
motivation.

What programs do you use to edit your works?
I edit using Photoshop and Illustrator.

¿Cual es tu inspiración?
Todas las cosas lindas en el mundo son mi inspiración.
La fantasía, los caramelos, las cute girls y los animales,
esta combinación es mi motivo de inspiración.

¿Que programas usas para editar tus trabajos?
Me gusta editar mis trabajos con Adobe Photoshop y
Adobe Illustrator.

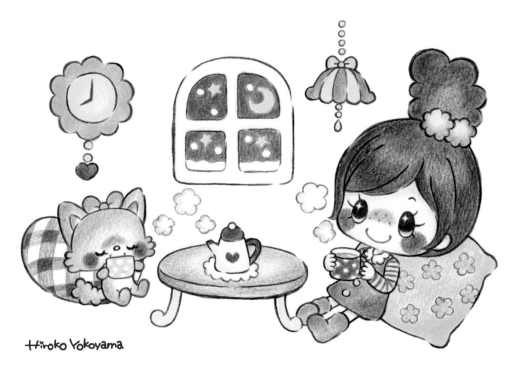

Hiroko Yokoyama

Tea time of midwinter

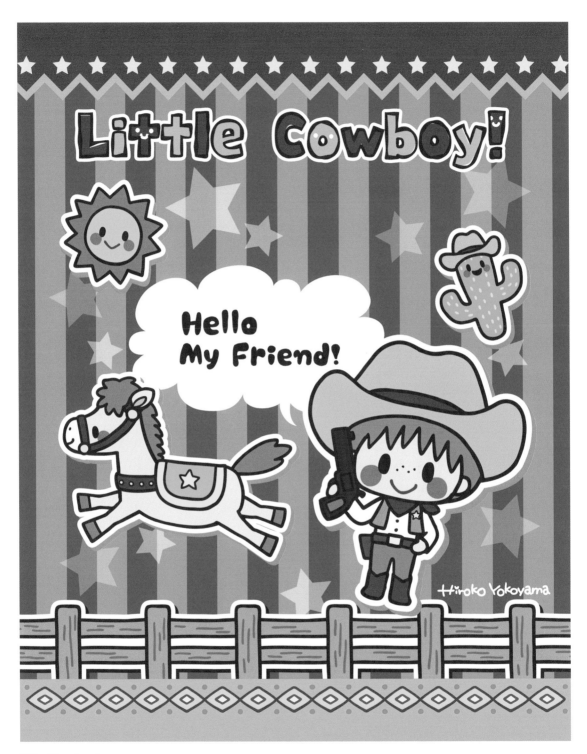

Little Cowboy!

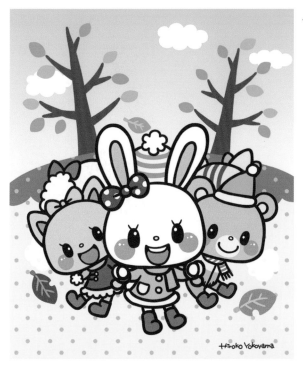

A push and shove game

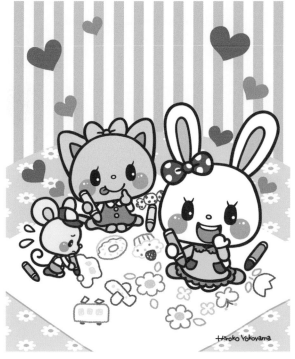

Graffiti

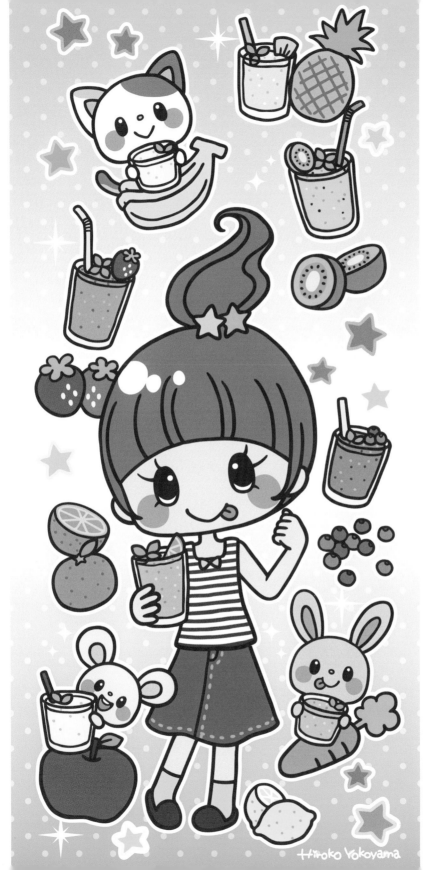

Hiroko Yokoyama

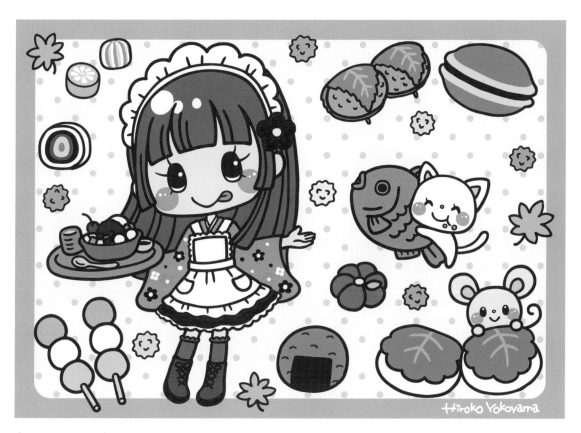

Japanese sweets

In the following pages: Aloha

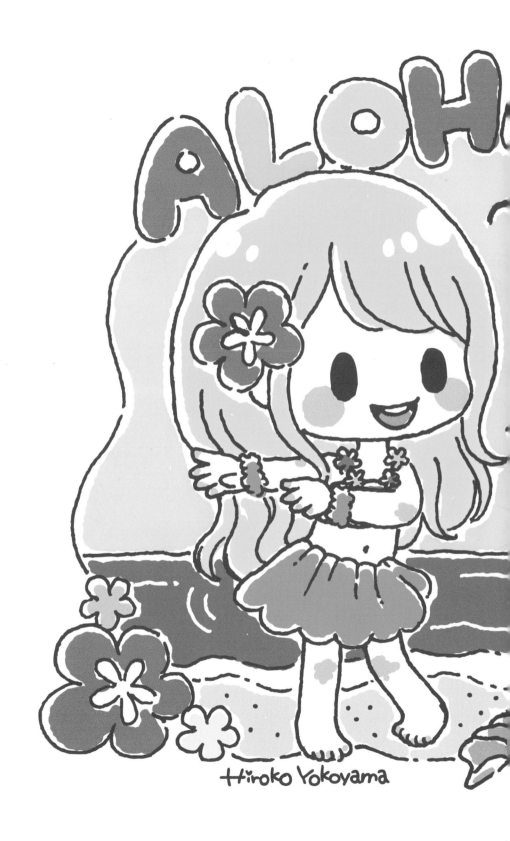